IMAGES
of America

ELK RIVER

On the cover: **ELK RIVER DEPOT, 1900.** Please see page 50. (Sherburne History Center.)

IMAGES
of America

ELK RIVER

Debra J. Mortensen

ARCADIA
PUBLISHING

Published by Arcadia Publishing
Charleston SC, Chicago IL, Portsmouth NH, San Francisco CA

Printed in the United States of America

Library of Congress Control Number: 2009933027

For all general information contact Arcadia Publishing at:
Telephone 843-853-2070
Fax 843-853-0044
E-mail sales@arcadiapublishing.com
For customer service and orders:
Toll-Free 1-888-313-2665

Visit us on the Internet at www.arcadiapublishing.com

This book is dedicated to the men and women who bravely left the comfort and safety of their homes, moved west, and settled Elk River.

CONTENTS

ACKNOWLEDGMENTS

The majority of the photographs used here were generously donated to the Sherburne History Center. My sincere appreciation goes out to those individuals whose donations made this book possible. I would like to express my gratitude to Kurt Kragness and the staff at the Sherburne History Center, with a special thank you to Bobbie Scott, who scanned over 150 photographs. My thanks go out to Janet Panger for the Frye and Staples family photographs and Linda Kelly for the Moore family photograph. I would also like to thank the Minnesota History Center staff for their help in locating and providing vast amounts of research materials to my table and for scanning photographs and papers in their collection for this book.

On a personal note, I would like to thank Elk River mayor Stephanie Klinzing and the city council for their financial backing of this project and for approving my appointment to the Heritage Preservation Commission in 2007. I am grateful to my fellow commissioners, who have given me encouragement and free reign on this exciting adventure into Elk River's past. I would like to thank a few people from the community, including Capt. Brad Rolfe at the Elk River Police Department, Rob Dreissig at the Elk River Fire Station One, and the ladies at the Elk River Senior Center and the Elk River Activity Center for arranging my visits in May 2009. I would also like to thank my daughter Savant Mortensen, who helped organize photographs and made my meals during the last week before the book was due. Lastly I wish to thank my editor at Arcadia Publishing, Ted Gerstle, for answering my questions and being excited about this book. I hope you enjoy reading about the city of Elk River as much as I enjoyed writing about it.

INTRODUCTION

Many of the original names found in old Elk River records can be traced to other locations in Minnesota. Zebulon Pike, Henry Mower Rice, Pierre Bottineau, and Ard Godfrey all left their mark on Minnesota after leaving Elk River. The Native American phrase *wich a wan*, meaning "where two rivers join," was a perfect description of where the city of Elk River developed. Elk River is located on a line between the woodlands and prairies. It was also on a dividing line between the Dakota Indian and Ojibwa Indian lands, remaining a contested area for several generations. The two tribes frequently clashed over hunting and fishing rights here. According to William A. Warren's account of Ojibwa tradition, the Ojibwa and Dakota tribes fought two battles in 1772 and 1773. The area was referred to as *me-gaud-e-win-ing*, meaning "battleground." Land in Sherburne County remained a contested issue between the tribes even after the 1825 treaty was signed that created a boundary between them.

Between 1840 and 1870, Red River oxcarts passed through Orono on their way from Pembina to St. Paul. The oxcarts followed the Metropolitan Trail along the north shore of the Mississippi River and crossed the Elk River in its southeast quarter section. A military road was established to Fort Gaines (Fort Ripley) along the same path as the Metropolitan Trail and Woods Trail in the 1850s. The military road crossed at the Elk River in Big Lake Township and then joined the oxcart trail on the southeast side of Elk River. Jefferson Highway and the railroad line now generally follow the original path of the military road and the Metropolitan Trail.

David Faribault built a trade post in 1846 in what became Orono. The trade post was then sold to Henry Mower Rice and Simeon Pearl Folsom in 1847. Folsom built a cabin and brought his family to settle there. He then sold the trade post to Bottineau in 1848. A small number of men and farmers began to settle in the area. Silas Lane, Oliver H. Kelley, and a Mr. Morah were among the first. In 1849, Bottineau moved his trading post to lower town and hired carpenter Francis Delill from St. Anthony to build a hotel. Delill shared the cabin owned by Morah while he constructed the building. When the Elk River House was completed, Bottineau purchased the cabin from Morah and turned it into a small tavern. In 1894, the original cabin was torn down after serving many years as a tavern and then as a storage shed. In 1850, Ard Godfrey, a well-known name in the milling industry, and his brother-in-law John G. Jameson purchased Silas Lane's farm and water rights. They built a dam and sawmill on the Elk River, and the following year they added a gristmill. The dam built by Godfrey and Jameson created the Mill Pond, later called Lake Orono. They hired Eddy Dickey of St. Anthony to build the dam, and when he was finished, he decided to stay. Orono was the first settlement, platted in 1855 by Godfrey, who named it after his hometown in Maine. The original plat consisted of 19 blocks of

land along the southern shore of Lake Orono, which did not exist at the time. Bottineau's land was listed for sale in the St. Anthony *Express* in March 1853, and the property listed for sale in the upper country included a large tavern, a store building, a separate dwelling, and barns and stables. John Quincy Adams Nickerson purchased the land.

The lumbering business was in decline in Maine, and many of the workers were looking for new opportunities. During the 1850s and 1860s, 10 Heath family members headed west, settling in Orono. On June 27, 1857, Alden B. Heath had his land—two blocks on the large peninsula of Lake Orono—surveyed and platted, and this became known as Heaths Addition to Orono. It included Orono Cemetery, which is the oldest cemetery in Elk River. His land was bordered by that of Godfrey to the west, Jul Le Croix to the east, Jameson to the north, and the Mississippi River to the south.

In 1853, a shallow draft steamboat named *Governor Ramsey* began making trips on the Mississippi River from St. Anthony to Sauk Rapids, picking up passengers and freight. Steamboats and stern-wheelers were vital to the people living along the Mississippi River; they depended on them to transport farm products to market and deliver needed supplies. Wheat and grain were the most important items shipped.

Elk River survived the great financial crisis that hit the country from 1858 through 1860. The crisis started out east and quickly spread to the west.

During the Civil War, around 28 men ranging in age from 17 to 39 enlisted from Orono and Elk River. Many of the soldiers who came to call Orono and Elk River their home after the war were wounded or captured at well-known battles including Antietam, Bull Run, Chaplin Hills (Perryville), Gettysburg, and Murfreesboro. After the Civil War ended, over 23 enterprising soldiers moved to Orono and Elk River to farm and open businesses.

By the fall of 1864 the railroad extended to Elk River. It would be the end of the line until the fall of 1866. The coming of the railroad brought a business boom in just a few years. The two-block stretch paralleling the tracks on the north side was filled with new establishments. The business street was called State Street and followed about the same route as today's Railroad Drive. By the mid-1870s there were approximately 18 stores along State Street. In 1867 the county seat moved to Elk River, and in 1868 the post office relocated to Elk River.

In 1881 Orono and Elk River incorporated and became known as Elk River. The two townships were separated by a large, thick grove of trees. Reminders of Orono remain today in many locations around Elk River including Lake Orono (originally known as Mill Pond), Orono Cemetery, Orono Road, and Orono Parkway.

In 1882 Colonel Heath and brothers George and Will Gay became proprietors of the Blind Pig Saloon. The saloon had numerous disturbances and fights throughout the years and was dynamited in 1885.

Elk River suffered a large number of disastrous fires during its early days. In 1887, a fire burned most of the businesses in upper town. In April 1898 in the business block on the north side of the tracks, 20 businesses burned in three hours. In June 1898 the starch factory and livery stables burned. In March 1901 the flour mill owned by the Elk River Milling Company burned, destroying over 5,000 bushels of wheat. In January 1903 the magnificent Houlton Brick Block burned. In 1907 Elk River experienced seven major fires of undetermined cause, and in January 1911 the post office block on Main Street went up in flames. Several smaller fires claimed additional buildings until 1920.

In 1916 Elk River streets had electricity for the first time.

One

UPPER COUNTRY

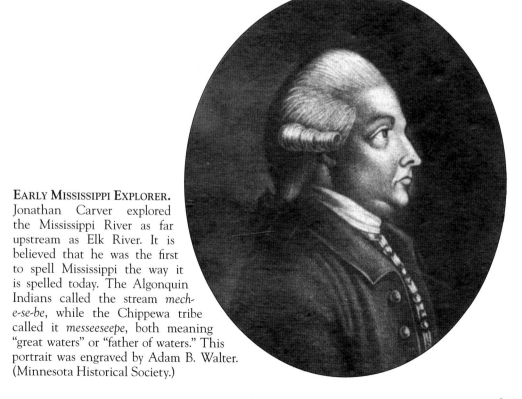

EARLY MISSISSIPPI EXPLORER.
Jonathan Carver explored
the Mississippi River as far
upstream as Elk River. It is
believed that he was the first
to spell Mississippi the way it
is spelled today. The Algonquin
Indians called the stream *mech-
e-se-be*, while the Chippewa tribe
called it *messeeseepe*, both meaning
"great waters" or "father of waters." This
portrait was engraved by Adam B. Walter.
(Minnesota Historical Society.)

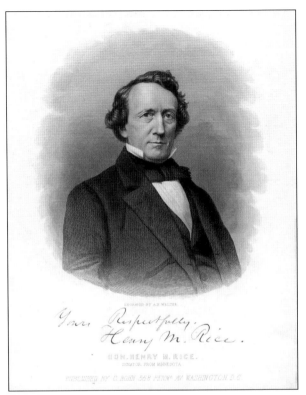

WHITE RICE. Henry Mower Rice was a suttler, or supply clerk, at Fort Snelling when he was 23 years old. All his life he was in competition with Henry H. Sibley, first in the fur trade business and then in politics. He was nicknamed "White Rice" by the Chippewa Indians on account of his honesty. He purchased the upper country trade post in 1847 from David Faribault. (Minnesota Historical Society.)

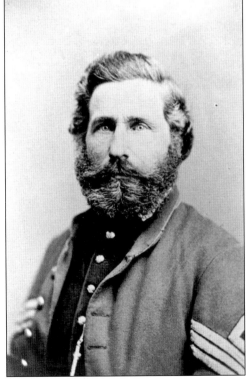

SIMEON PEARL FOLSOM. Shown here in his Civil War uniform, Simeon Pearl Folsom purchased an interest in the trading post with Rice from Faribault in 1847. He built a cabin and brought his family from St. Anthony to live in what became Orono. (Joel E. Whitney, Minnesota Historical Society.)

PROMINENT GUIDE. In 1849, Pierre Bottineau took over the rustic trading post and tavern from Rice and Folsom. In 1850, he opened the Elk River House and stayed long enough to help found the township of Orono. Bottineau lived the life most men dreamed of. He was a trusted interpreter and spoke French, English, Dakota, Ojibwa, Cree, Mandan, and Winnibago. He served as a guide for the trading companies, the military, and the railroads. He was an excellent hunter, boatman, land speculator, adventure guide, and he knew how to survive harsh conditions. He became known as the "walking peace pipe" for his ability to smooth disagreements between the Dakota and Ojibwa Indians, white settlers, and others. He married twice and had 24 children. He was born to voyageur Charles Bottineau and Margaret "Clear Sky" Ahdik Songab. (Minnesota Historical Society.)

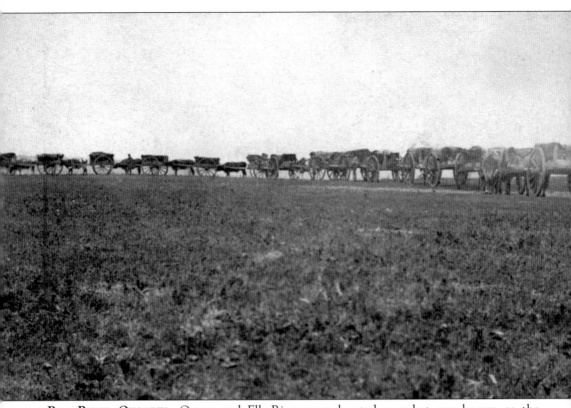

RED RIVER OXCARTS. Orono and Elk River were located on what was known as the Metropolitan Trail. The Red River oxcarts traveled from the Pembina region of Canada down to St. Paul to trade furs for supplies. The trail generally followed the north shore of the Mississippi River and crossed at the Elk River in the southeast quarter of section 33. Each cart was tied to the previous one; sometimes 200 carts were in a line. The wheels cut deep into the ground, and some of the old trails are still visible on private lands today. (Whitney's Gallery, Minnesota Historical Society.)

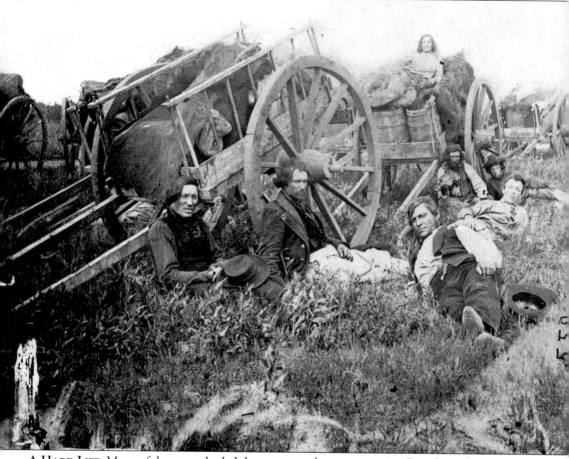

A HARD LIFE. Many of the men who led the carts were known as *metis*, a French word meaning, "person of mixed race," and they often descended from Cree, Ojibwa, Saulteaux, and Menominee women and European men, mainly French. Controversy and disagreement over who is *metis* is still being debated today. (Minnesota Historical Society.)

GRANGE FOUNDER. Oliver H. Kelley was one of the first to farm along the Mississippi River in 1850. The site was called Itasca, and it was located between Elk River and Anoka. He was a cofounder of the National Grange of the Order of Patrons of Husbandry in Washington, D.C., on December 14, 1867. This marked the birth of organized agriculture. (Sherburne History Center.)

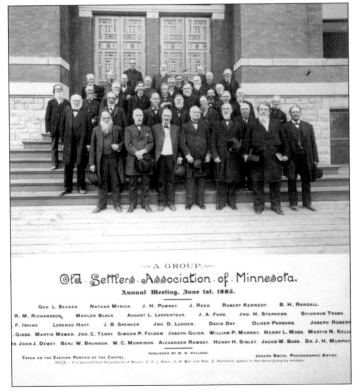

OLD SETTLERS ASSOCIATION OF MINNESOTA. In 1885, a group consisting of some of Minnesota's earliest pioneers got together at an annual meeting of the Old Settlers Association. Among those pictured is Simeon Pearl Folsom. (Joseph Roberts, Minnesota Historical Society.)

Two

BRIDGES, DAMS, AND MILLS

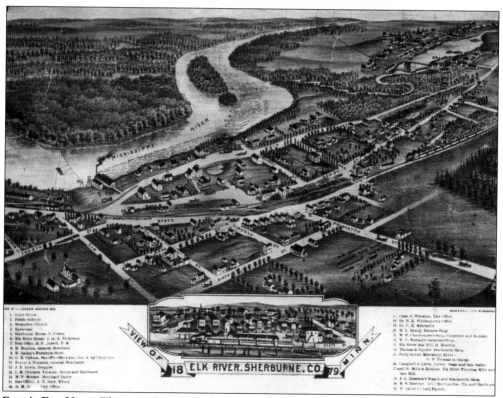

BIRD'S-EYE VIEW. This map from 1879 shows how Orono and Elk River looked. Notice the ferry crossing on the Mississippi River. (Sherburne History Center.)

ARD GODFREY. In 1850, Ard Godfrey and his brother-in-law John G. Jameson purchased Silas Lane's farm and water rights along the Elk River. They built a dam and a sawmill and then added a gristmill the following year. In a letter to his wife, Nancy, Jameson told her how much the area looked like Maine. This may explain why so many people from Maine settled here. (Minnesota Historical Society.)

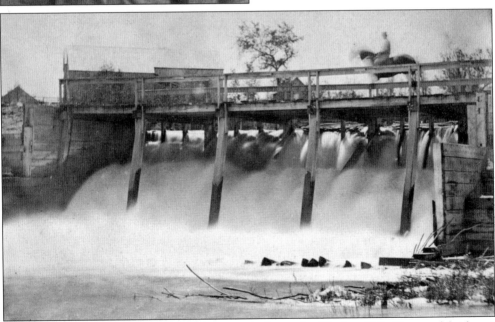

ELK RIVER DAM, 1870. This early photograph shows the Timber Crib Dam and bridge at Orono. In the spring of 1851 Eddy Dickey was hired by Ard Godfrey and James G. Jameson to build the first dam in Orono. He decided to stay and work in the first sawmill. In 1862 Ard Godfrey mortgaged the farm to rebuild the dam, which had been swept away. (A. M. Hulbert Art Gallery, Minnesota Historical Society.)

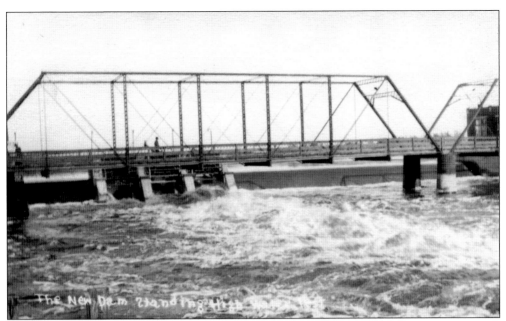

NEW DAM AND BRIDGE. On July 27, 1905, the bridge from Elk River to Otsego was started. It was 266 feet long and 75 feet above water. However, two feet had to be trimmed off the smoke stacks of the boom company steamboats to pass under the bridge. There were numerous problems during construction, including one accident that left Frank Hall hurt and Will Staples and Charles Wheaton shaken. (Sherburne History Center.)

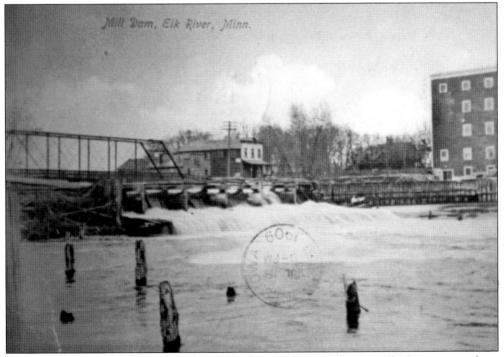

MILL DAM, 1909. Here is a postcard showing the mill dam in Elk River. The Iowa postmark on the back dates this picture from July 18, 1909. (Sherburne History Center.)

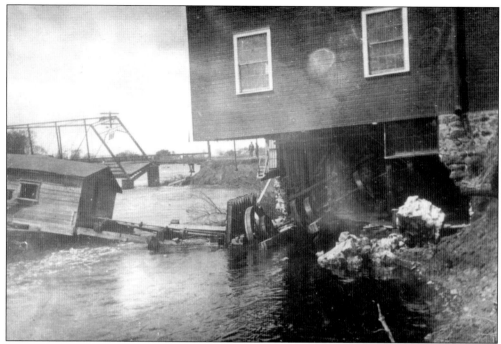

HIGH WATER. Spring flooding in 1912 washed out the dam, flume, and separate wheel house on the left, and undermined the foundation under the Elk River Milling Company. The flour mill was closed at the time of the damage. The flooding also washed away the east approach to the bridge, just above the dam. In October 1913, the machinery was sold to Shane Bros. & Wilson in Hastings, Minnesota. (Sherburne History Center.)

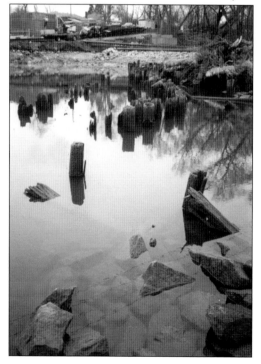

HOULTON DAM AND MILL REMAINS, 1991. Here are the remains of the old Houlton dam and mill in Elk River when water levels were low enough to make the ruins visible. (Sherburne History Center.)

ELK RIVER SAWMILL. This photograph from 1893 shows what the sawmill looked like. Logs have collected along the river bank. (Sherburne History Center.)

HOULTON SAWMILL ADVERTISEMENT FROM JANUARY 24, 1889. In 1894 Houlton's Elk River Sawmill had two million feet of logs ready to go once the ice went out on the Mississippi and operations commenced. In January 1902, William Houlton sold his sawmill on the Mississippi to B. N. Thompson of Minneapolis for around $4,000. (Sherburne History Center.)

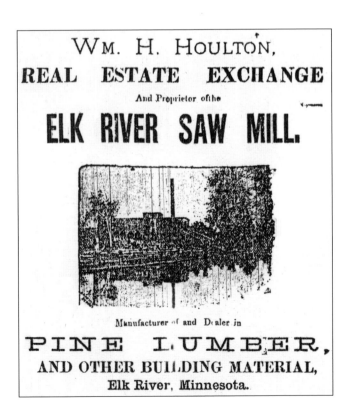

WM. H. HOULTON,
REAL ESTATE EXCHANGE
And Proprietor of the
ELK RIVER SAW MILL.

Manufacturer of and Dealer in
PINE LUMBER,
AND OTHER BUILDING MATERIAL,
Elk River, Minnesota.

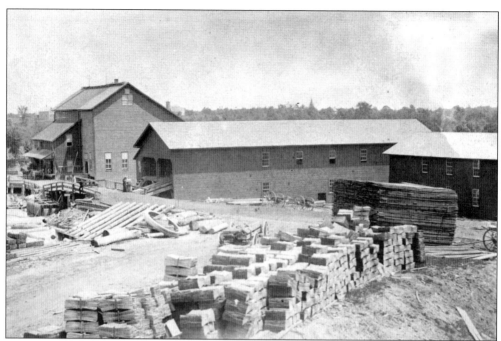

OLD FLOUR AND PLANNING MILL. This photograph shows the flour and planning mill in Elk River before the buildings burned in 1887. (L. H. Filmore, Minnesota Historical Society.)

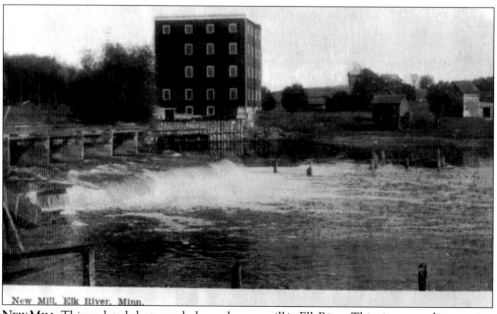

New Mill, Elk River, Minn.

NEW MILL. This undated photograph shows the new mill in Elk River. This gives a good impression of what the surrounding area looked like at one time. (Minnesota Historical Society.)

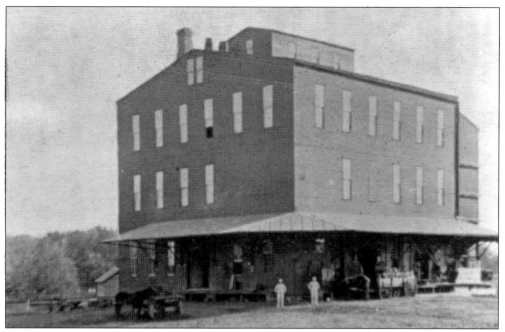

FLOUR MILL, 1898. The *Sherburne County Star News* printed this photograph of the flour mill on December 1, 1898. (Sherburne History Center.)

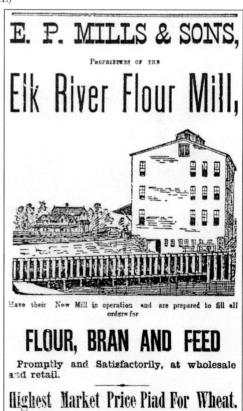

E. P. MILLS AND SONS. This advertisement announced that the new Elk River Flour Mill was open for business in January 1881. (Sherburne History Center.)

E. P. MILLS & SONS,

PROPRIETORS OF THE

Elk River Flour Mill,

Have their New Mill in operation and are prepared to fill all orders for

FLOUR, BRAN AND FEED

Promptly and Satisfactorily, at wholesale and retail.

Highest Market Price Piad For Wheat.

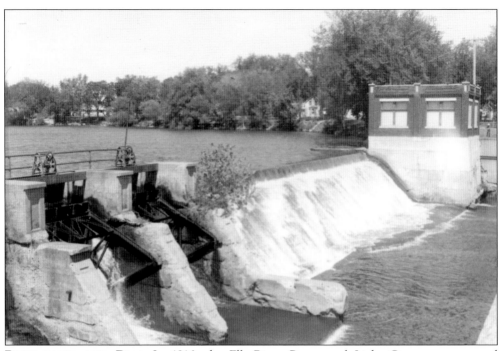

POWERHOUSE AND DAM. In 1916, the Elk River Power and Light Company generated hydroelectricity with a single 220-horsepower turbine. Elk River finally had electricity and streetlights. (Sherburne History Center.)

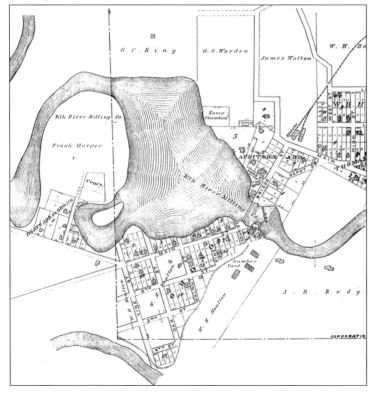

1903 ORONO PLAT. This is a page from the plat book of Sherburne County, compiled from county records and actual surveys. (Sherburne History Center.)

Three

ELK RIVER

HISTORIC LANDMARK. This log cabin, believed to be the oldest building in Elk River, was torn down in December 1894. In 1850, Pierre Bottineau built the small tavern and hotel with limited amenities. In 1852, John Quincy Adams Nickerson, Frank Nickerson, and Frank Hildreth bought the cabin, hotel buildings, and 160 acres comprising most of the village of Elk River for $1,500. (Sherburne History Center.)

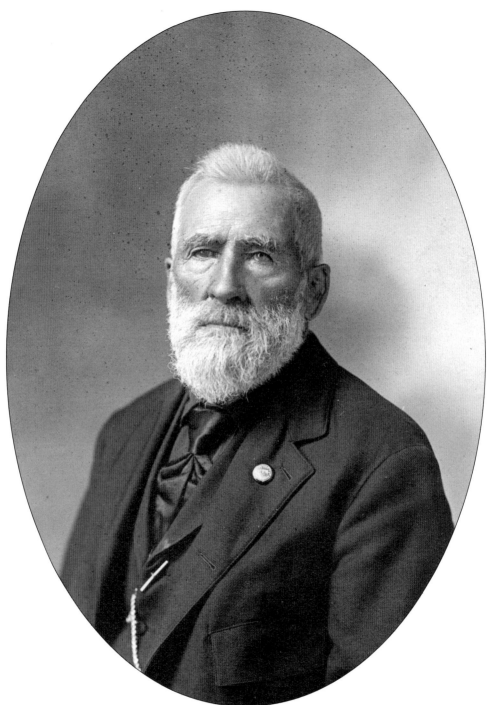

GRAND OLD MAN. John Quincy Adams (J. Q. A.) Nickerson, or "Quinn" to his friends, was one of the first pioneer leaders in Elk River. During his 64 years living in Elk River, he engaged in the lumber business, owned a large farm, was proprietor of the Elk River House, and served as Elk River's first postmaster in 1853. In 1880, he was elected Sherburne County treasurer. In 1907, Nickerson and his son Clifford became Master Masons. (Sherburne History Center.)

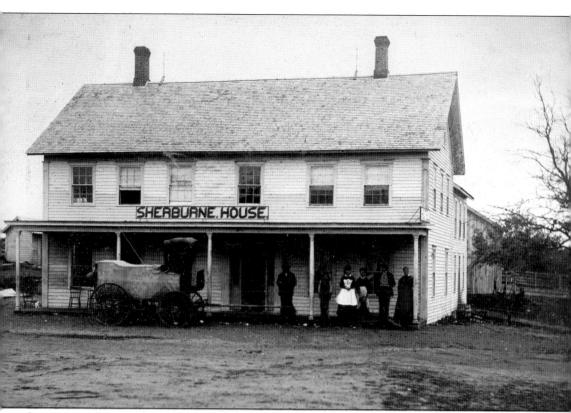

SHERBURNE HOUSE. In 1870, the Sherburne House was built by proprietors Samuel Colson and E. Davis near the train depot in lower town. In 1893, the building's name changed to the Merchant Hotel. Other early owners included Amaziah Trask and J. P. Taylor. This tintype of the Sherburne House is from 1879. (Sherburne History Center.)

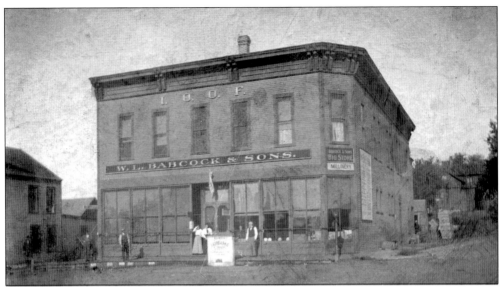

W. L. BABCOCK AND SONS. Willard L. Babcock came to Elk River in 1880. He opened W. L. Babcock and Sons along with his sons Willard G., Charles M., and Edmund Pope. (Sherburne History Center.)

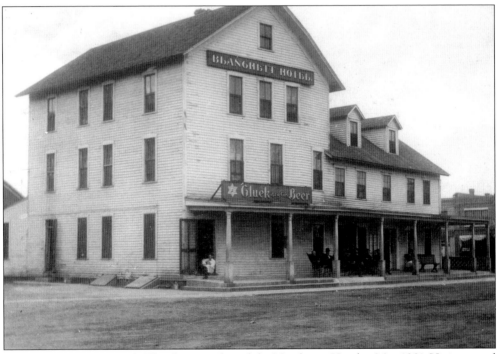

BLANCHETT HOTEL. M. C. Blanchett purchased the Merchants Hotel in May 1901. He improved the property with water closets, hot and cold water, and an artesian well. It was the only first-class hotel in the city. Over the course of its lifetime, it had many owners and three name changes. This was the second hotel built in Elk River. (Sherburne History Center.)

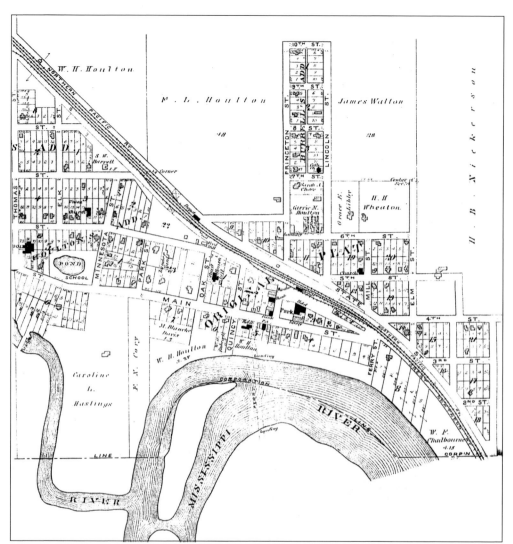

1903 ELK RIVER PLAT. This is a page from the plat book of Sherburne County, compiled from county records and actual surveys. (Sherburne History Center.)

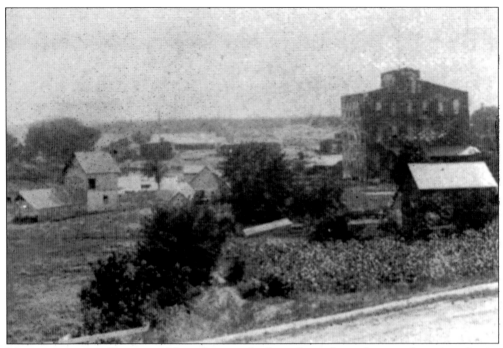

MANUFACTURING DISTRICT. This photograph shows how the early manufacturing district looked in Elk River, with houses and buildings all together. (Sherburne History Center.)

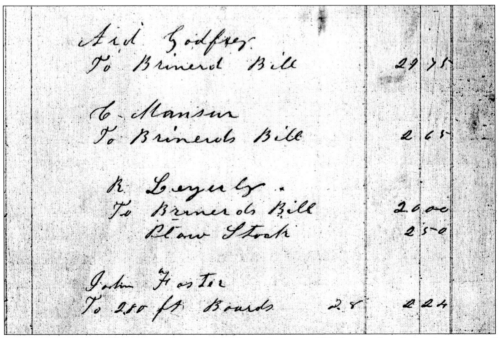

SAW MILL LEDGER. This image shows a page from the saw mill ledger and includes the names of Ard Godfrey, Charles Mansur, and Robert Leyerly. (Sherburne History Center.)

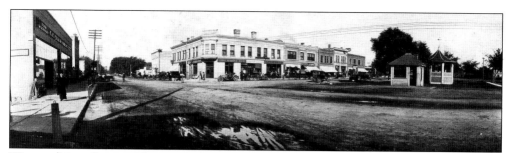

WEST ON MAIN STREET. This view looks west on Main Street in Elk River with the Houlton building in the center. This photograph was taken on October 6, 1916. (Sherburne History Center.)

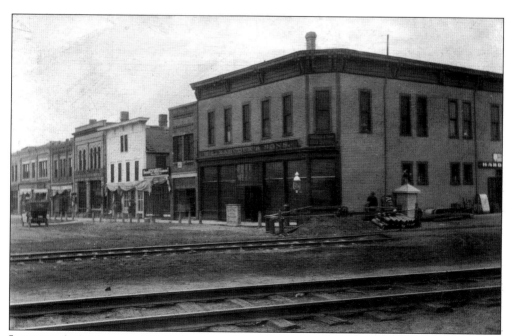

JACKSON AVENUE, C. 1900. This scene shows the west side of present-day Jackson Avenue looking south. The old Babcock store is on the corner. (Sherburne History Center.)

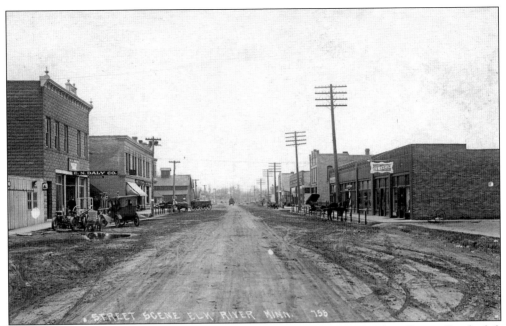

EAST ON MAIN STREET. This postcard view of Elk River looks east on Main Street. On the left side, the E. N. Daly store, the First National Bank, the bandstand, and the feed barn for the Blanchett Hotel are visible. The photograph was taken after 1903. (Sherburne History Center.)

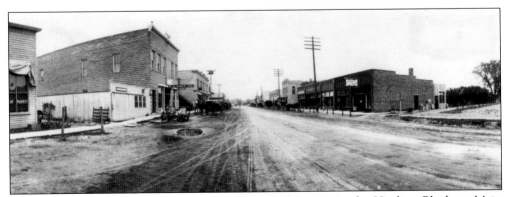

HOULTON BLOCK ON MAIN STREET. Seen here looking east is the Houlton Block on Main Street in Elk River. The meat market is visible on the far left in this photograph from the early 1900s. (Sherburne History Center.)

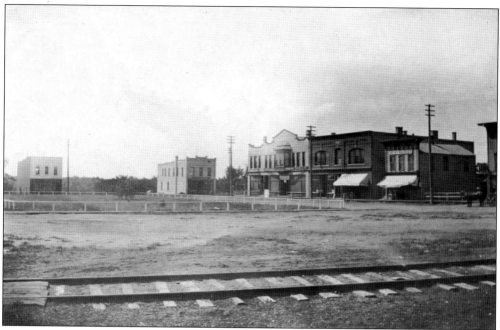

ELK RIVER SQUARE. Here is an early view of downtown Elk River showing the square that later had the bandstand, the Romdenne building (just left of center), and the railroad tracks in the foreground. The photograph was taken before 1903, when the current Houlton building was constructed. (Sherburne History Center.)

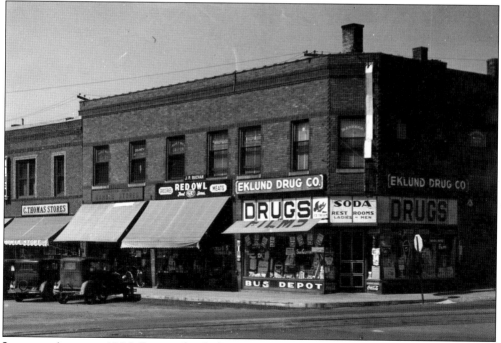

JACKSON AVENUE, 1924. Present-day Jackson Avenue in downtown Elk River is pictured here. Visible businesses include Eklund Drug Company, Red Owl, Gamble Stores, C. Thomas Stores, and a hotel. (Sherburne History Center.)

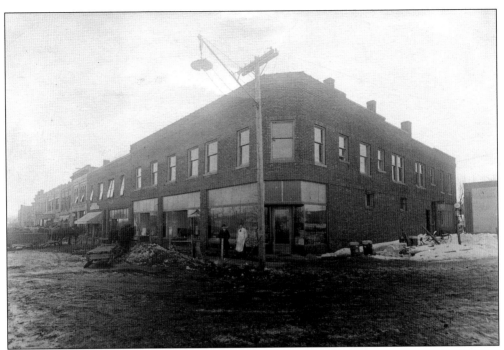

DOWNTOWN VIEW, 1920. This photograph shows downtown Elk River on present-day Jackson Avenue. On the corner is the Babcock building that later housed Eklund Drug Company. (Sherburne History Center.)

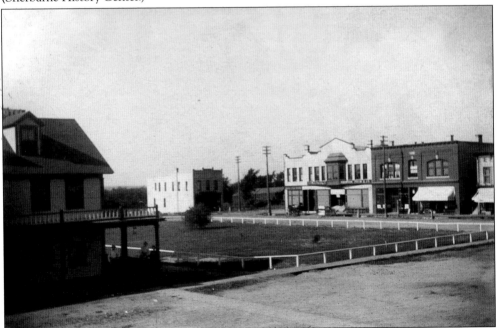

BUSINESS DISTRICT. This view of downtown Elk River shows the Blanchett Hotel at left, the Romdenne drugstore just left of center, and the widest side of Jackson Avenue to the right. The Houlton building has not yet been constructed on the corner, so this photograph was taken before 1903. (Sherburne History Center.)

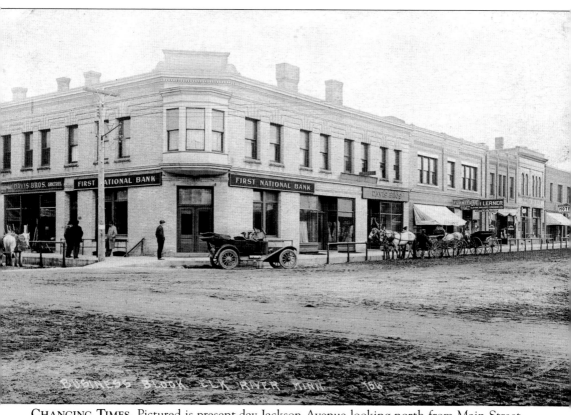

CHANGING TIMES. Pictured is present-day Jackson Avenue looking north from Main Street. Seen is the Houlton building with the First National Bank, Davis Brothers, J. T. Plante groceries, R. Dare Furniture, physician and surgeon C. E. Page, Lerner Clothing, Plank, the Bank of Elk River, and a hotel. Wagon teams and automobiles share the dirt streets. (Sherburne History Center.)

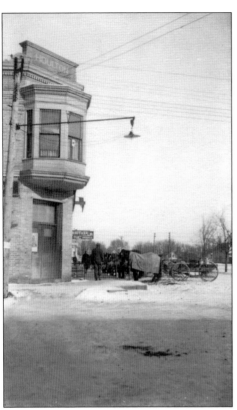

HOULTON BUILDING AND STREETLIGHT. This building was built in Elk River in 1903. The photograph shows a streetlight. (Sherburne History Center.)

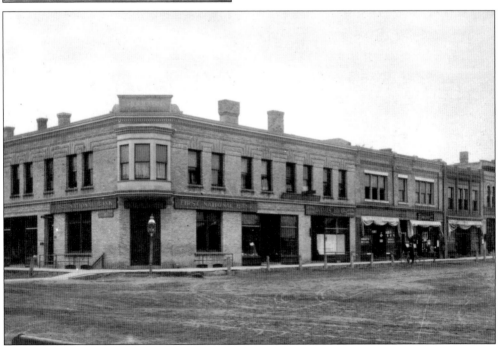

FIRST NATIONAL BANK. This 1908 corner photograph shows the Houlton Block with the First National Bank of Elk River. (Sherburne History Center.)

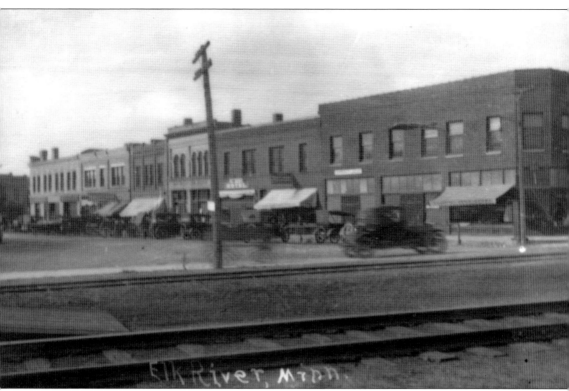

LOOKING SOUTH ON JACKSON AVENUE. Here is a photograph from the 1920s of Jackson Avenue looking south. From right to left are the brick Babcock building, unidentified, a hotel, and the Bank of Elk River. (Sherburne History Center.)

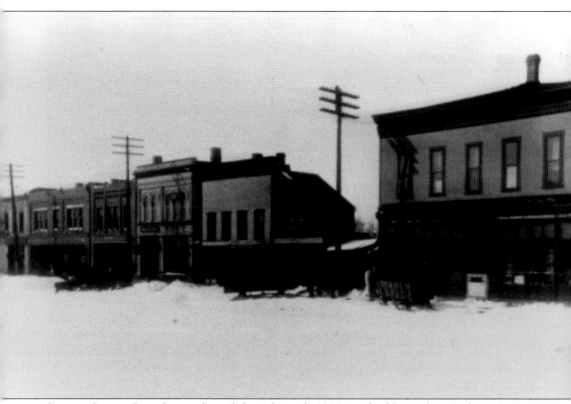

STREET SCENE. Seen from right to left in the early 1900s are buildings along Jackson Avenue, including the W. L. Babcock and Sons store, the Frank Thurston White office, and the Bank of Elk River. (Sherburne History Center.)

Four

A CALL TO ARMS

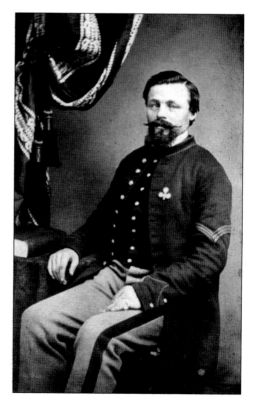

WOUNDED AT BULL RUN. Anson R. Hayden from Elk River enlisted in 1861. He served three years in Company I, First Regiment Infantry Minnesota Volunteers and was wounded on July 21, 1861, at Bull Run. During his service, he was promoted to corporal and sergeant, and on May 5, 1864, he was discharged with his regiment. He was the son of Samuel and Mary Hayden. (Minnesota Historical Society.)

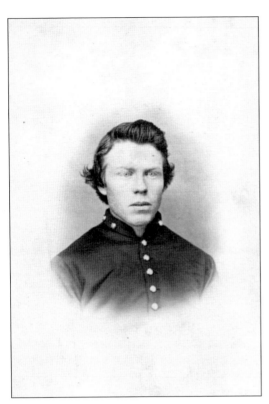

BROTHERS IN ARMS. Charles B. Hayden from Elk River enlisted in 1861 at age 30. He served in Company C, First Regiment of Mounted Rangers. He then served in Company E, First Minnesota Heavy Artillery, along with his brother Isaac and their cousin Wentworth; they were all discharged on September 27, 1865. Charles and Isaac were the sons of Samuel and Mary Hayden. (Minnesota Historical Society.)

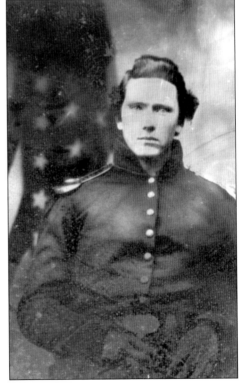

SECOND LIEUTENANT. Adelbert Bryant served in Company B, Hatchs Independent Battalion Minnesota Calvary from May 21, 1861, until he was discharged for disability of the lungs on January 26, 1863. He then served with Company D, First Minnesota Infantry. Bryant was promoted to first sergeant at age 22 on June 28, 1863, and second lieutenant on July 6, 1865. (Minnesota Historical Society.)

WOUNDED AT CHAPLIN HILLS. Daniel Lee Frye was 39 years old when he enlisted in the Second Battery Light Artillery Minnesota Volunteers. During the battle of Chaplin (Perryville) Hills, Kentucky, on October 8, 1862, Frye was wounded in the ankle by a musket ball. He then served with Company B, 138th Indiana Infantry Rail Road Guard for 100 days in 1864. (Sherburne History Center.)

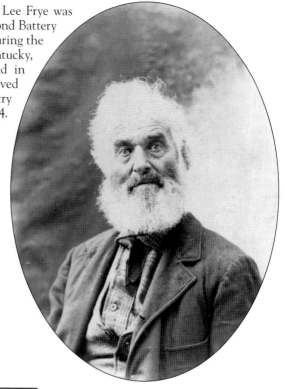

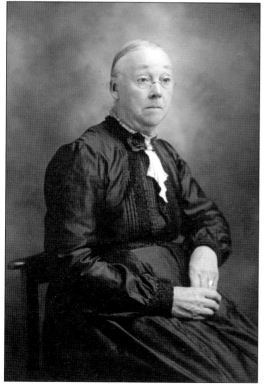

SOLDER'S WIFE. Mary M. Rand had four children with her husband Julian Rand, who enlisted at age 29 in the First Company Minnesota Sharp Shooters on October 5, 1861. He then served with Company A, Second Regiment Berdans U.S. Sharp Shooters. (Sherburne History Center.)

39

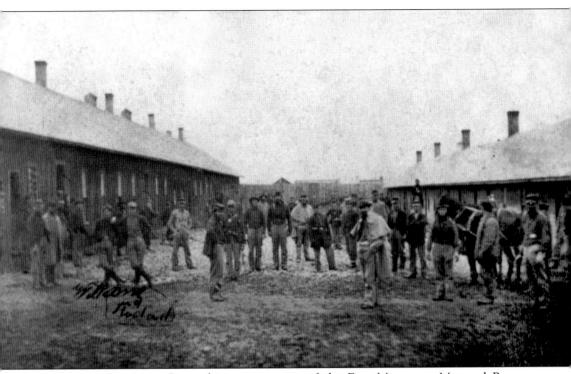

MOUNTED RANGERS. Posing here is a portion of the First Minnesota Mounted Rangers, including George Crocker, a blacksmith from Orono who enlisted at age 20 and also served with Company H, Third Minnesota Infantry. (Minnesota Historical Society.)

ABIGAIL (REED) TRASK. Pictured here is the wife of Amaziah Trask, Abigail (Reed) Trask, who came to Elk River in 1866. They married on February 28, 1839. Amaziah conducted the stagecoach route with H. P. Burrell. During the summer of 1880, he purchased the Sherburne House. (Sherburne History Center.)

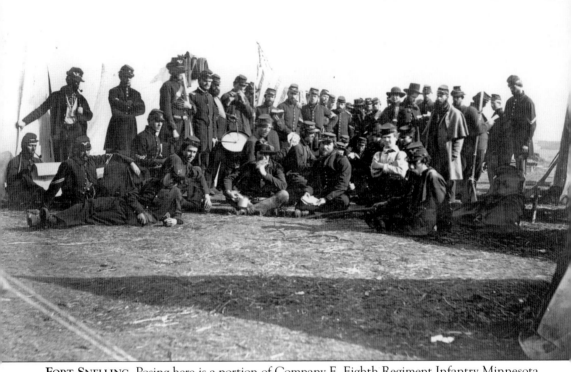

FORT SNELLING. Posing here is a portion of Company E, Eighth Regiment Infantry Minnesota Volunteers. Two men enlisted from Orono, including Henry W. Fuller, who was wounded at Murfreesboro, and 18-year-old George Tourtillatte, who transferred to the Third Minnesota Battery of Light Artillery. Two men from Elk River who enlisted were Levering Holgate and John H. Felch, who were both 32 years old. William Henry Houlton enlisted at age 22 and moved to Elk River after the Civil War. He authored the *Narrative of the Eighth Regiment*. After defending the western frontier for about a year, The Eighth Regiment proceeded south, and its first battle was at Murfreesboro. The regiment was known for its never-ceasing strength. (Benjamin F. Upton, Minnesota Historical Society.)

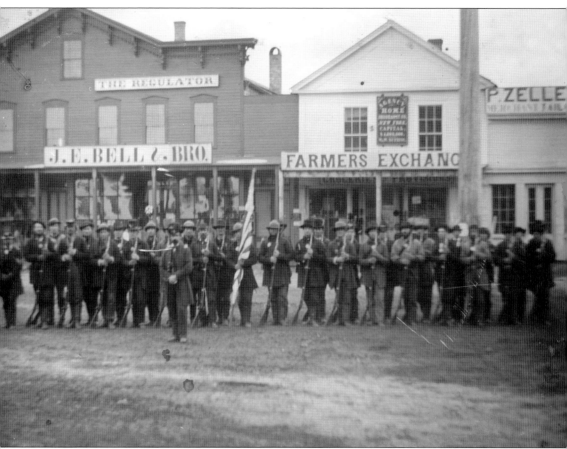

WOUNDED AT GETTYSBURG. Company D, First Regiment Minnesota Infantry Volunteers are posed here at the northeast corner of Nicollet Avenue and First Street in Minneapolis. Benjamin F. Noel began serving with this regiment. He then served with Company C, U.S. Veteran Volunteer Infantry from May 20, 1861, to May 5, 1864; he was discharged with this regiment. Noel collected a pension of $6 a month for being wounded in his left leg at Gettysburg. He moved to Elk River after the war. (Minnesota Historical Society.)

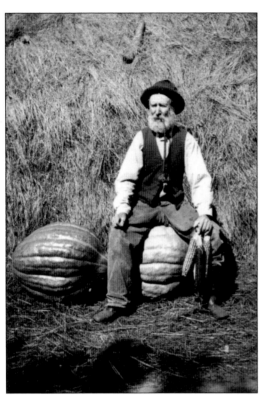

WILLIAM BROWN BECK. William Brown Beck is shown here sitting on a pumpkin. He served with Company A, Eighth Regiment Infantry Minnesota Volunteers as a corporal. He participated in several engagements and was slightly wounded in one. Others who served with him include Walter D. Gay, Charles H. Hancock, Robert W. Leyerley, Henry S. Mansur, and Alden B. Heath. (Sherburne History Center.)

CAPT. P. T. WOODWARD. Posing for this picture is Capt. P. T. Woodward, possibly wearing his Grand Army of the Republic pins and ribbons. (Sherburne History Center.)

Five

WHEELS, RAILS, AND THE RIVER

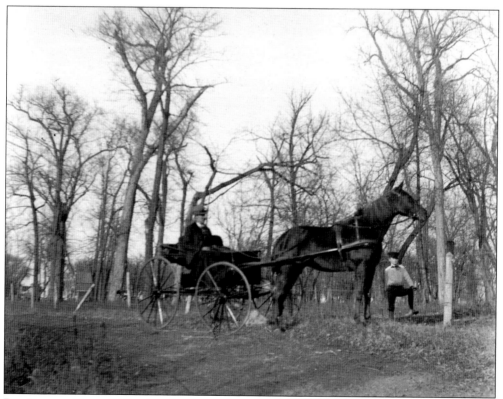

DR. ROBERT TODD. Riding in a fine horse-drawn buggy is Dr. Robert Todd. The other person in the photograph is unidentified. (Sherburne History Center.)

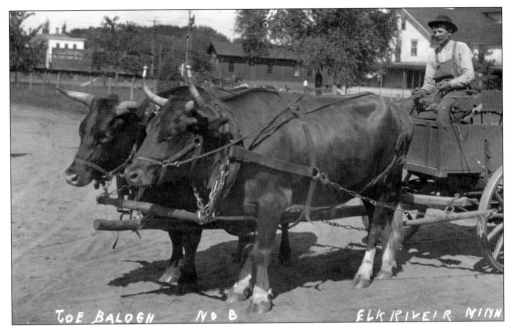

OXEN TEAM. Hungarian immigrant Joe Balogh is pictured with his oxen team carrying a load of potatoes in Elk River about 1914. From left to right in the background are the August Meyer building, the depot, and the Blanchett Hotel. The team is facing the main part of town towards Big Lake. Balogh was later killed in a wedding brawl. (Sherburne History Center.)

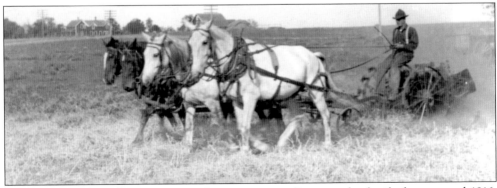

POTATO DIGGER. Will Frye is pictured using a potato digger on the family farm around 1916. The farmhouse is in the distant background. (Sherburne History Center.)

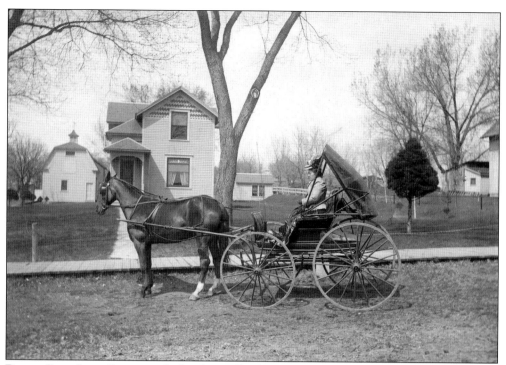

BUGGY RIDE. Lucia Davis is parked in front of her home. Notice the wooden sidewalk. (Sherburne History Center.)

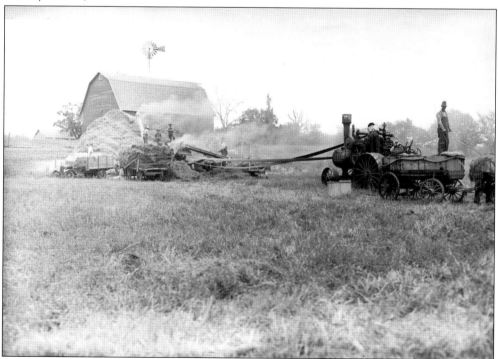

THRESHING MACHINE, 1914. This photograph shows a threshing machine, a crew of workers, and a steam engine on the Spect farm. (Minnesota Historical Society.)

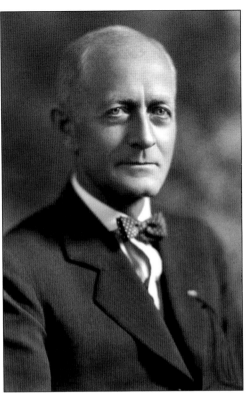

CHARLES M. BABCOCK. After moving to Elk River when he was young, Charles M. Babcock became interested in highway development and was appointed to the state highway commission as the executive officer. As a young man, he took a few courses. When the panic of 1893 occurred, he left college and went to work in his father's store with his brothers. (Lee Brothers, Minnesota Historical Society.)

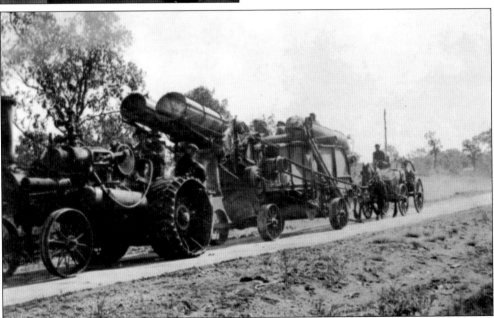

GOOD PROGRESS. Progress is being made on the paved Jefferson Highway from Elk River to the Anoka County line. W. S. Harris Company, contractors on the project, substituted tray rock for gravel. The tray rock was superior, and the authorities expressed no complaints. The Elk River City Council drew out $1,177.48 from the road and bridge fund to build the road. (Minnesota Historical Society.)

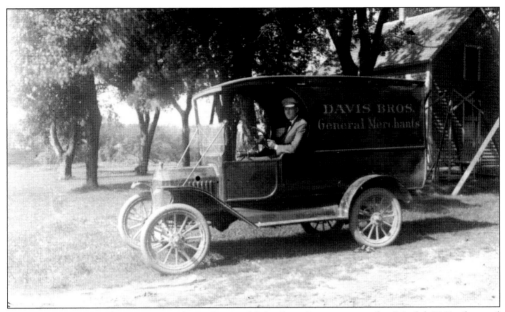

MODEL T FORD. The Davis Brothers General Merchandise store used a Model T Ford panel truck as a delivery vehicle, pictured here in 1902. (Sherburne History Center.)

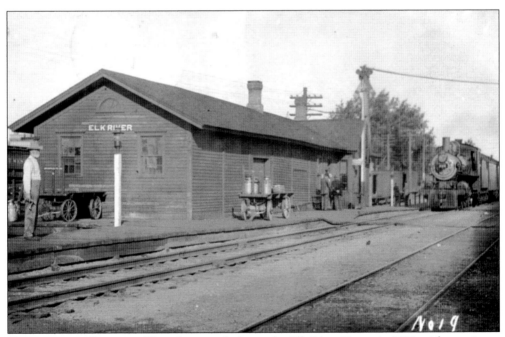

TRAIN AT THE STATION. This photograph shows the Elk River Depot in 1911, with a train on the track, work carts, and people. (Minnesota Historical Society.)

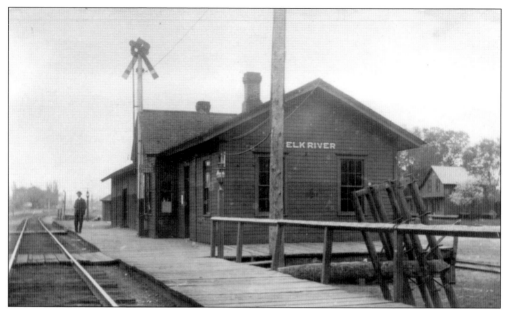

DELIVERING FIREFIGHTERS. In January 1903, a devastating fire spread rapidly, and help was quickly asked for by telegraph. Minneapolis sent fire engine No. 9, with Chief Kahor in charge. They came on the Great Northern Railway, but by the time they arrived, the fire was under control. Even though it wiped out an entire block in three hours, a hard fight was won to save the new Bank of Elk River. (Sherburne History Center.)

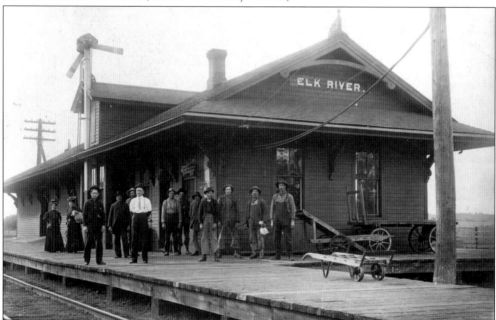

ELK RIVER DEPOT, 1900. The sign above the door says, "Great Northern Express Co." Passengers are awaiting the arrival of the train at the station in Elk River. The first trains arrived in Elk River in the fall of 1864; this was the last stop on the line. It only took six hours to travel the 30 miles from Minneapolis to Elk River. To speed things along, passengers would help stock wood in Itasca. (Sherburne History Center.)

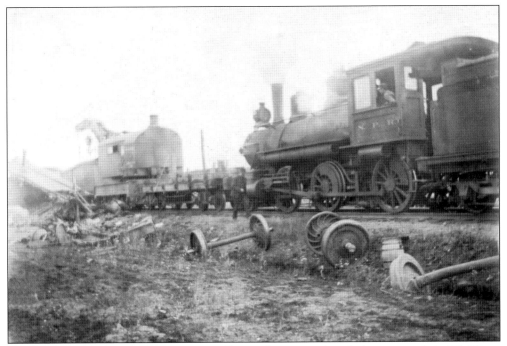

TRAIN WRECK IN ELK RIVER, C. 1900. Pictured is an unidentified train wreck in Elk River, with a Northern Pacific Railway steam locomotive, train parts in the ditch beside it, and a block and tackle moving wreckage off the tracks in front of it. (Sherburne History Center.)

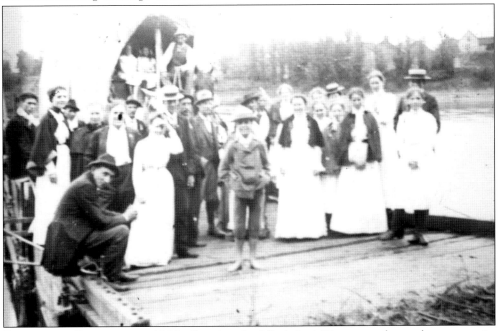

DANGEROUS CROSSING, C. 1900. Crossing the Mississippi River was often a dangerous trip. Numerous drownings of people and livestock were reported in local newspapers. High water, ice flows, and log drives all took their toll on the residents of both sides of the river. These unidentified riders are catching the Elk River ferry. (Sherburne History Center.)

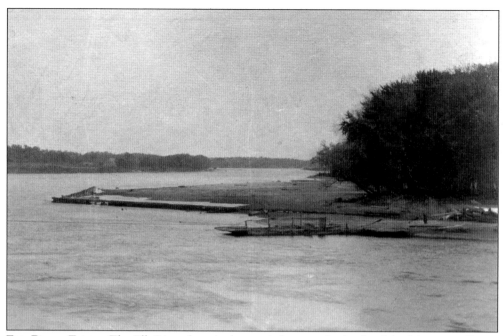

ELK RIVER FERRY. The Elk River ferry is shown tied up on the bank of the Mississippi River. Without a way to get across the river, ferries played a crucial role in transporting people and goods to the other side. Various men ran the ferries over the years, including John McDonald, Thomas Nickerson, Horatio Houlton, George Thomas, and Prosper Vassar. (Sherburne History Center.)

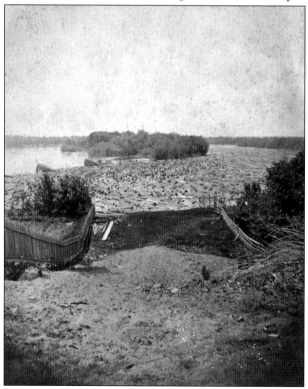

LOGS ON THE MISSISSIPPI RIVER. This is a stereoscope card photograph taken by L. H. Fillmore of a logjam on the Mississippi River around 1900. In August 1899, there were an estimated 75 million feet of logs on the Mississippi River between Elk River and St. Cloud. The Boom Company had two steamboats and about 100 men working with the logs, and the sawmill in Elk River ran night and day. (Sherburne History Center.)

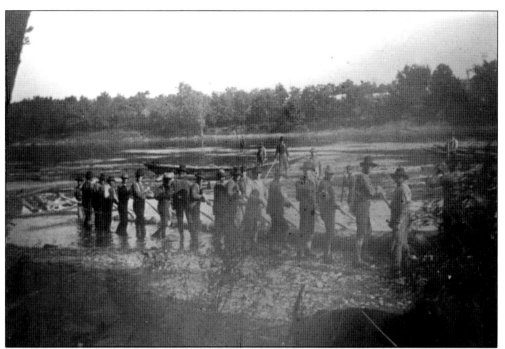

STRANDED LOG. Standing shoulder to Shoulder, a work crew is pushing a stranded log off the bank into the main current of the Elk River in 1909. (Sherburne History Center.)

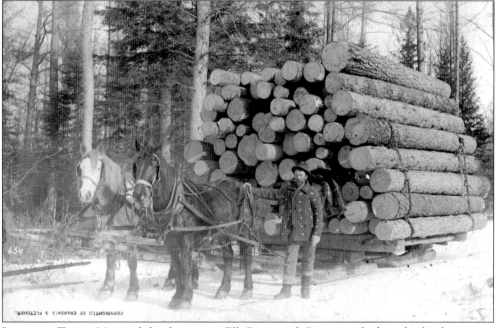

LOGGING TEAM. Many of the farmers in Elk River and Orono worked in the lumber camps during the winter; this photograph shows how high logs were stacked. Once the logging business came to an end around 1910, most farmers had to find another source for a second income. (Sherburne History Center.)

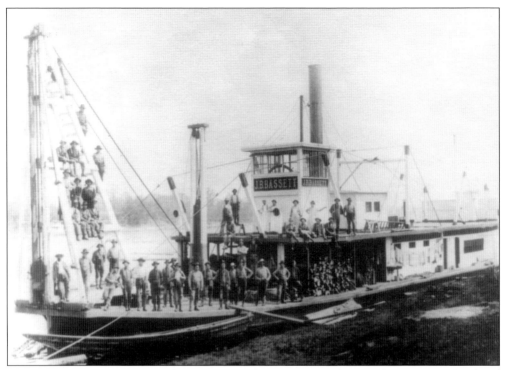

***J. B. Bassett* Steamboat.** In the 1850s, steamboats made regular trips between St. Cloud and St. Anthony Falls. The boats carried passengers and freight upstream and wheat downstream until the late 1860s. The steamboats often stopped at Elk River, and when they did, the business people put down planks of wood to protect their floors from the long spikes on the raft men's boots. (Sherburne History Center.)

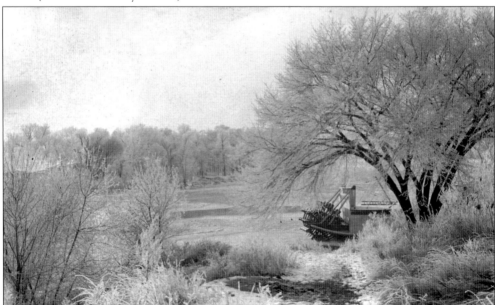

Caught in the Ice. A stern-wheeler is caught in the ice on the Mississippi River near Elk River. Ice is covering the branches of the trees. (Sherburne History Center.)

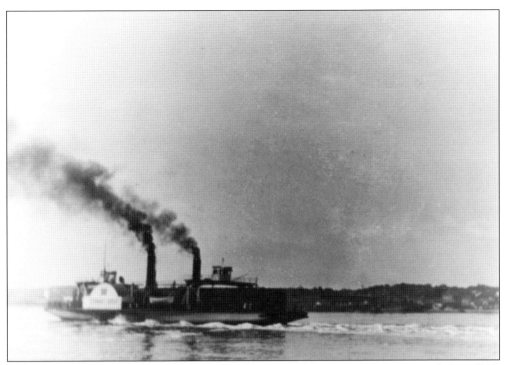

STERN-WHEELER. A stern-wheeler is busy working on the Mississippi River in 1918 or 1919. (Sherburne History Center.)

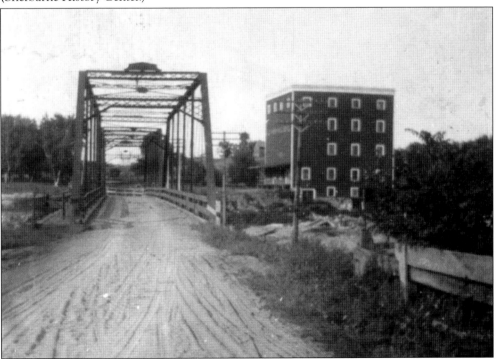

BRIDGE ACROSS ELK RIVER. This undated photograph shows the old bridge across the Elk River with the flour mill on the right. (Sherburne History Center.)

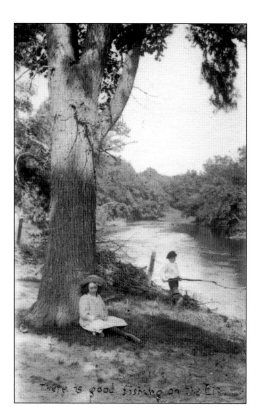

FISHING ON THE RIVER. Benjamin and Lillian Keays are fishing on the Elk River in 1915. (Sherburne History Center.)

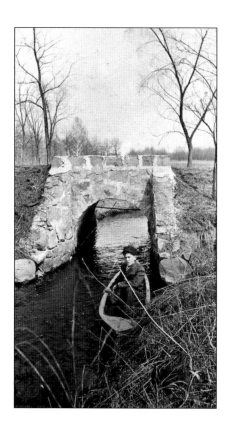

STONE BRIDGE. Robert (Bert) Trask of Elk River is pictured in a boat under a stone bridge in the early 1900s. (Sherburne History Center.)

Six

BUSINESS GROWTH AND PEOPLE

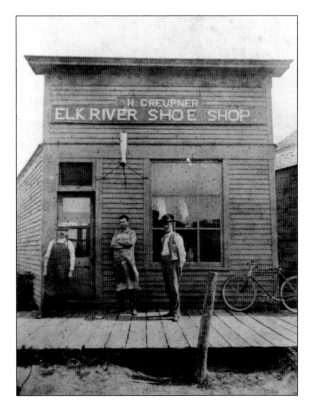

GREUPNER SHOE SHOP, 1890. German immigrant Herman Greupner came to Elk River in April 1884 after being informed that Minor L. Brand had room in his harness shop for a shoemaker to start a business for himself. The shop was located next to the general store owned by Henry Wheaton on the north side of the railroad tracks. Greupner had a reputation of turning out the best boots. (Sherburne History Center.)

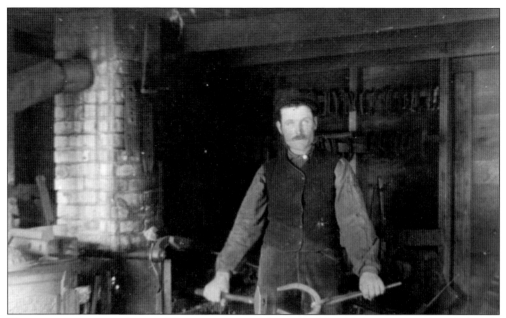

HAMMERING AT THE ANVIL. This picture was taken in 1890 and shows an unidentified early blacksmith in his shop. He is pounding and shaping a horseshoe using an anvil; the forge is to the left. George Crocker, John G. Jameson, Henry Larson, George Martineau, Oscar Peterson, Thomas Squire, Thomas Heath, Dan Hjerpe, and Joe Stone were among the men who made their living as blacksmiths. (Sherburne History Center.)

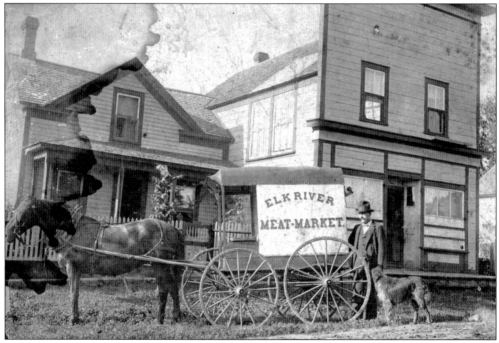

ELK RIVER MEAT MARKET. Posing for this 1895 photograph is John Blocker with his meat market wagon. Blocker was born in Germany and his wife, Amelia, was from Prussia. They had seven children, all born in Minnesota. (Minnesota Historical Society.)

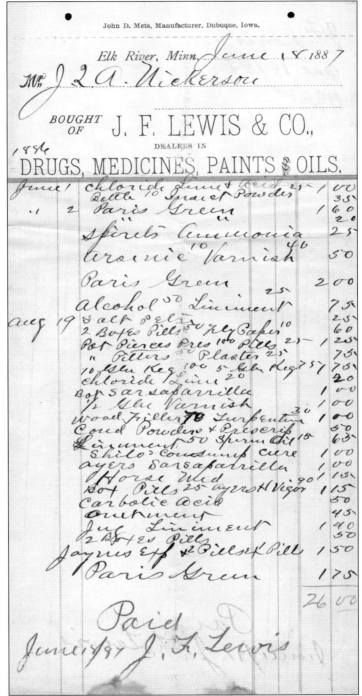

J. F. LEWIS AND COMPANY. John Frank Lewis was born in New York on May 18, 1850. In 1859, his family came to Minnesota, moving first to Monticello and arriving in Elk River in 1874. He engaged in the drugstore business under the name J. F. Lewis. On September 1, 1874, he married Hattie Albee of Elk River. Here is a receipt from the store showing a paid bill belonging to John Quincy Adams Nickerson. (Minnesota Historical Society.)

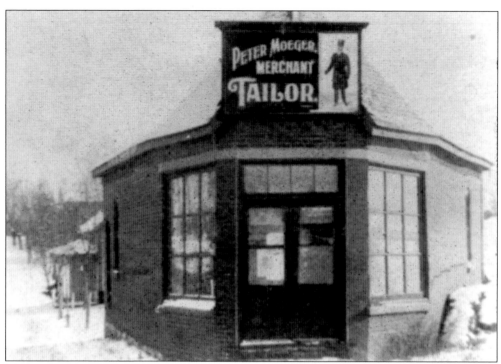

MERCHANT TAILOR. Peter Moeger was one of the best cutters and general tailors in the state. His word was as good as a bond. In 1880, he built a new store and added new partner C. Christenson. In 1892, he pulled up stakes and went to New Ulm; Mrs. Moeger and the family remained in Elk River. (Sherburne History Center.)

TAILORING BUSINESS ADVERTISEMENT. Peter Moeger placed this advertisement for his Merchant Tailoring Business in January 1891. His location was given as the "Little Brick Store" opposite the depot. (Sherburne History Center.)

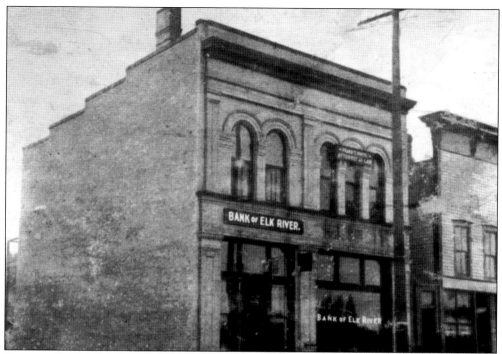

BANK OF ELK RIVER. In 1885, the First Bank in Sherburne County opened. Willard L. Babcock, William Henry Houlton, and Henry Castle invested $10,000 of their own money and opened the bank in Elk River on the corner adjoining Wheaton's Store. The deposits on the first day amounted to about $2,000. The county immediately made it their depository. Houlton sold his interest in the bank to his partners, who became sole owners in 1899. (Sherburne History Center.)

W**M**. H. H**OULTON**, Pre**st**. W. L. B**ABCOCK**, Vice-Pre**st**. H**ENRY** C**ASTLE**, C**ashier**

BANK OF ELK RIVER,

TRANSACTS A GENERAL
BANKING BUSINESS.

EXCHANGE FURNISHED,

Money to loan on Improved Farm Property
Represents First Class Insurance.

FIRST BANK IN COUNTY. This advertisement was placed in the *Sherburne County Star News* on January 24, 1887, by the Bank of Elk River. (Sherburne History Center.)

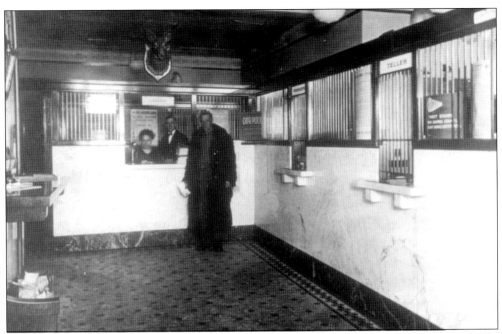

BANK OF ELK RIVER INTERIOR. This interior photograph shows the third home of the bank. After the disastrous fire in April 1915, the bank was forced to conduct business in a metal shed. The new bank offered a variety of services, including general banking business, a writer for fire insurance, and negotiated farm loans. (Sherburne History Center.)

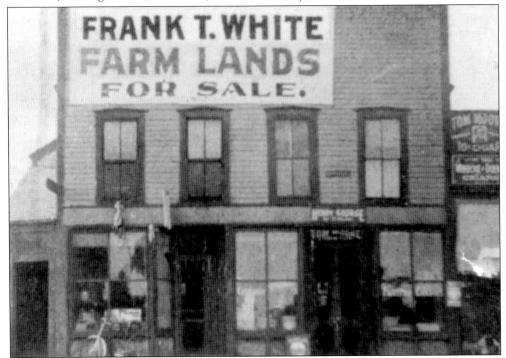

FARM LAND SALES. Frank Thurston White came to Elk River in 1873. He was an attorney in Elk River and then entered into land sales as settlers were pouring in. (Sherburne History Center.)

ROMDENNE DRUGS. The Romdenne drugstore sold medicine, jewelry, paints, oils, glass, stationery, and notions. By 1901, Romdenne had been in business for seven years after succeeding J. F. Lewis and Company, who established the business in 1880. Joseph H. Romdenne served as city clerk and was also on the city council. (Sherburne History Center.)

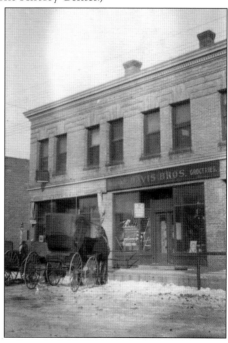

IRON HITCHING POSTS. This outdoor photograph of the Davis Brothers storefront shows the iron hitching posts for horses out front. (Sherburne History Center.)

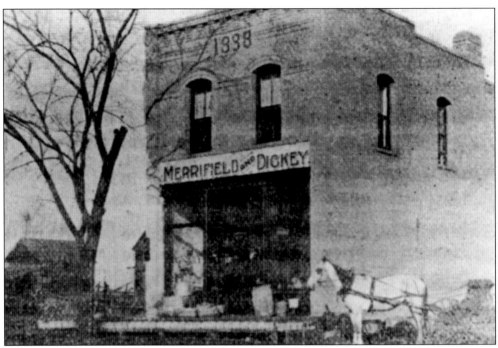

MERRIFIELD AND DICKEY, 1888. In 1901, Merrifield and Dickey advertised as a boot and shoe store. This storefront photograph shows a nice wooden boardwalk and a horse and carriage tied up. (Sherburne History Center.)

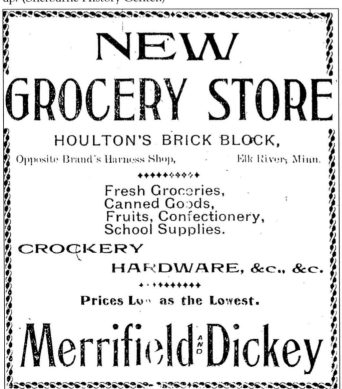

NEW GROCERY STORE

HOULTON'S BRICK BLOCK,

Opposite Brand's Harness Shop, Elk River, Minn.

Fresh Groceries,
Canned Goods,
Fruits, Confectionery,
School Supplies.

CROCKERY

HARDWARE, &c., &c.

Prices Low as the Lowest.

Merrifield and Dickey

MERRIFIELD AND DICKEY ADVERTISEMENT. This advertisement for the Merrifield and Dickey grocery store announced that it was located in Houlton's Brick Block. (Sherburne History Center.)

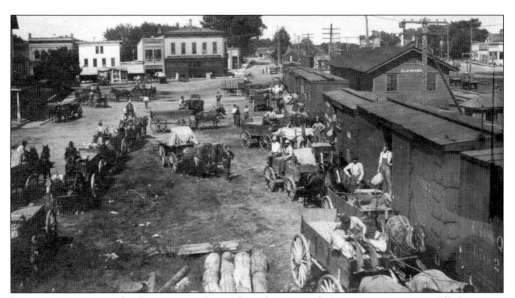

POTATO MARKET. The farmers are shown here bringing their potato wagons to Elk River on market day in the early 1900s. (Sherburne History Center.)

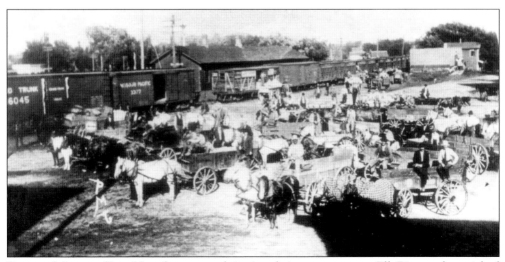

POTATO MARKET DAY. Here farmers are bringing their potato crop to Elk River to be weighed and sold to waiting buyers in the early 1900s. (Sherburne History Center.)

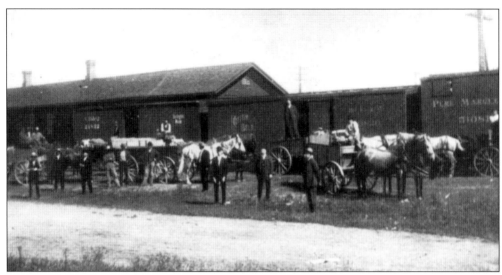

LOADING POTATOES. This postcard shows farmers lined up along the train, loading their potatoes after being purchased by a buyer. (Sherburne History Center.)

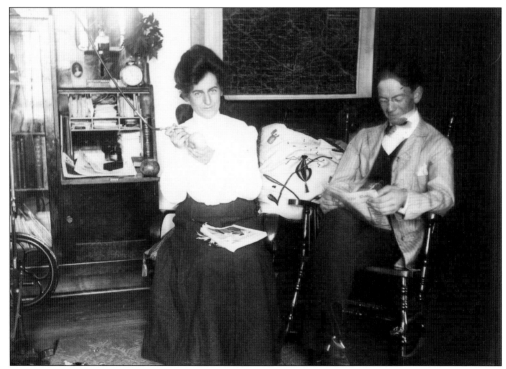

EARLY DENTIST OFFICE. A photograph taken by Perry Jones in 1910 shows an early dentist and his assistant in an office. Both are unidentified. In 1875, dentist Dr. G. W. Avery came to Elk River and set up shop in the lobby of the Sherburne House, spending a week pulling teeth and doing other dental work. (Sherburne History Center.)

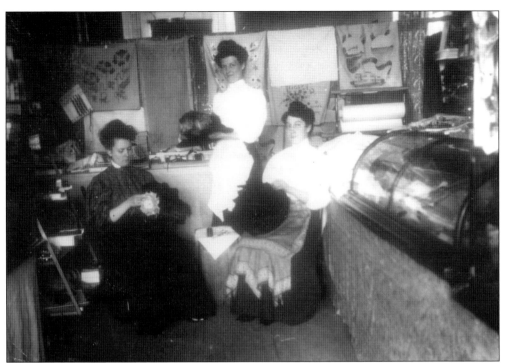

MILLINERY SHOP INTERIOR. Posing in the early 1900s, these unidentified young ladies are shown working at one of the few business avenues open to women. Lizzie Hall had the first millinery shop in Elk River, and Mrs. M. Gray opened the second one. Shops run by other women, including Mrs. H. O. Hawes, Mrs. C. H. Weldon, L. P. Taylor, and Nettie Mead, as well as Gerharts Millinery, were in existence in Elk River over the years. (Sherburne History Center.)

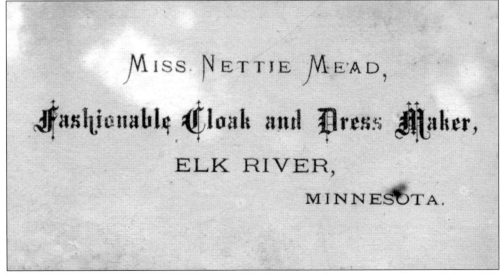

BUSINESS CARD. This business card was used by Mead to advertise her skills as a fashionable cloak and dressmaker. (Sherburne History Center.)

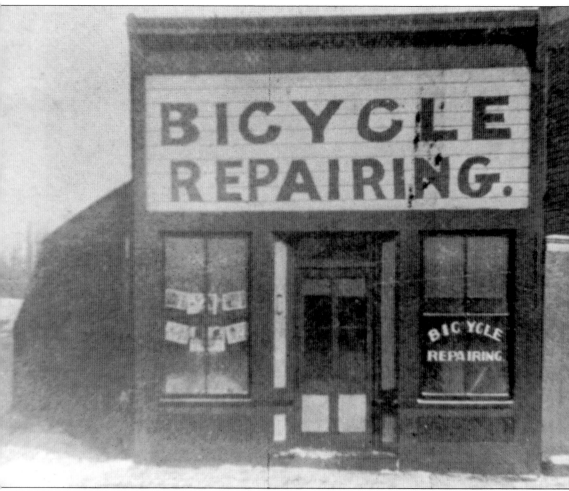

Bicycle Repairing, 1901. The Elk River Bicycle Club was organized on April 12, 1900, with about 25 members to start. In 1901 the club opened an excellent bicycle path from Itasca (the Oliver H. Kelley farm area) through Elk River to Big Lake. Heebner and Davis sold bicycle wheels in 1901. In 1907 buggies and horses were still a common form of transportation, but bicycles and trains were becoming more popular. (Sherburne History Center.)

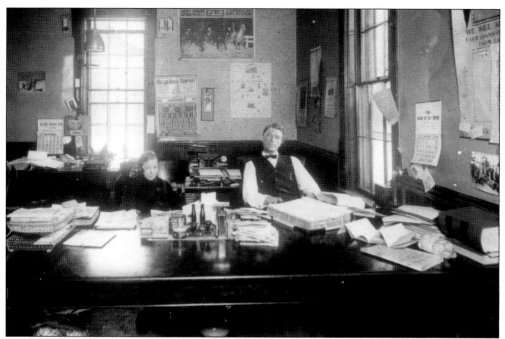

REGISTER OF DEEDS OFFICE. This photograph was taken in 1916. Anthony Byson was the register of deeds from 1913 to 1923. His daughter Ruth Byson (pictured) married Joe Flaherty of Elk River. (Sherburne History Center.)

SAFE DOOR. The safe in the Register of Deeds office was located in the Sherburne County Courthouse. This photograph was taken in 1989. (Sherburne History Center.)

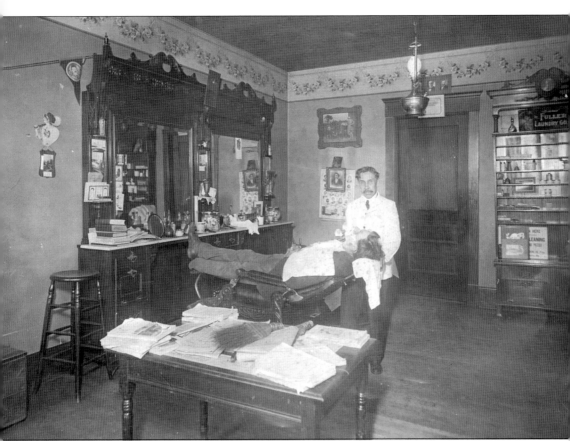

TONSORIAL ARTIST ENTREPRENEUR. Posing for this photograph is Perry Jones with an unidentified customer in his downtown barbershop. Jones lived his whole life on the Mississippi River. He moved to Elk River in 1883, and in 1890, he purchased the barbershop of Prof. H. B. Babcock. The shop was the finest, with elegant furnishings and all the modern improvements. Jones was born the son of a freed man in 1852. He was a member of the Union Congregational Church and the Elk River Community Band, and he was an amateur photographer. He was also an agent for the Mutual Accident Insurance Company of New York in 1889 and for Crescent Laundry. In 1890, Jones started to furnish a newsstand in his barbershop, which can be seen in the back to the right. Jones was a respected member of the community until his death in 1945. (Sherburne History Center.)

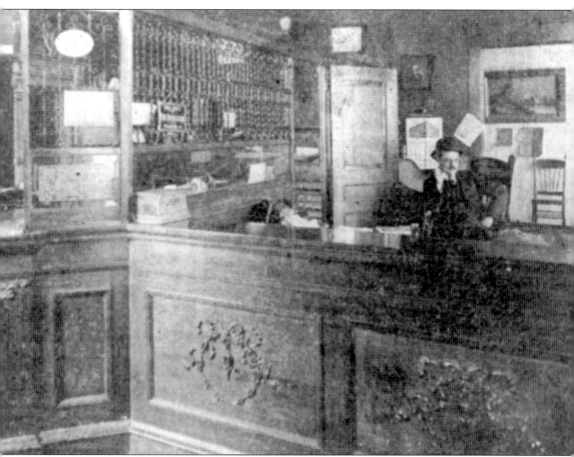

Basement Bank, 1903. This shows the interior of Houlton's basement bank after the fire of 1903 destroyed the original building. The bank was temporarily located in the basement room while the upstairs structure was being rebuilt. After completion, the bank moved to the main floor. The bank teller and customer are unidentified. (Sherburne History Center.)

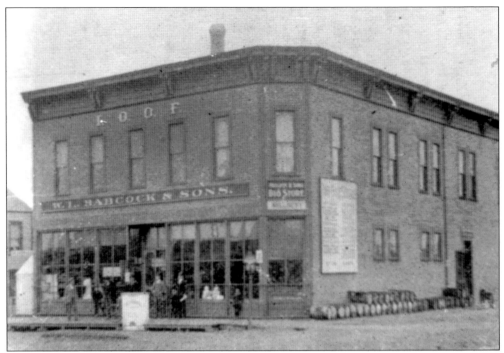

THE BIG STORE. Willard L. Babcock came to Elk River in 1880. He owned W. L. Babcock and Sons, known as the "Big Store," which sold a variety of merchandise including dry goods, clothing, cookery, groceries, glassware, shoes, hardware, building supplies, and farm machinery. (Sherburne History Center.)

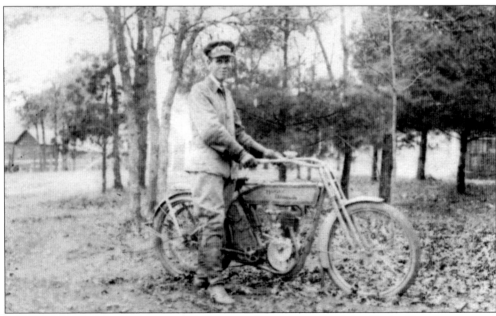

MAIL DELIVERY. Harold Keays, an Elk River mailman, is seen with his Harley Davidson around 1920. (Sherburne History Center.)

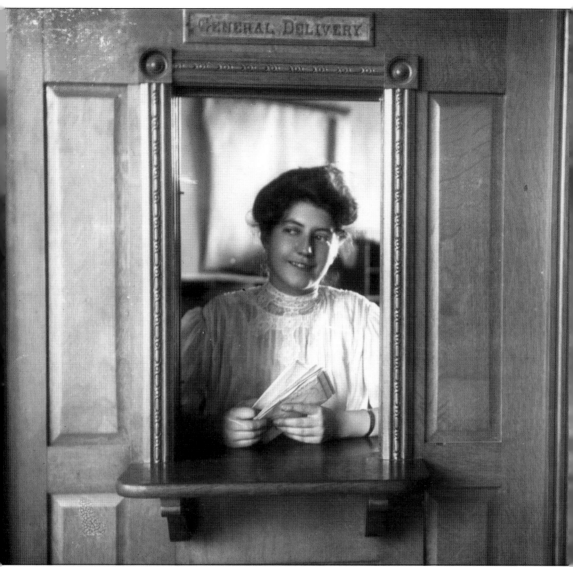

POST OFFICE. The woman posing for this photograph in the Elk River Post Office window is unidentified. The first post office in the area existed in Benton County from 1851 to 1867 and then transferred to Orono. In 1879, money orders were offered for the first time at the Elk River Post Office. In June 1906, the post office safe was blown open. Less than a month later, it was robbed again, but only a few books and a little change were taken. (Sherburne History Center.)

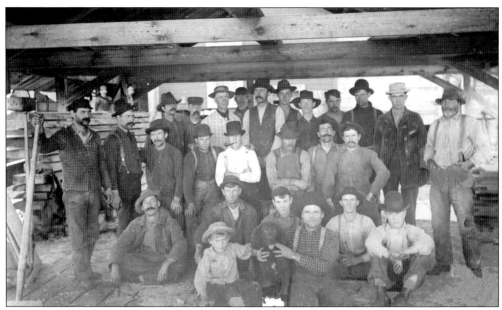

TAKING A REST. Posing for this picture is a group of unidentified men and boys taking a rest at the sawmill. (Sherburne History Center.)

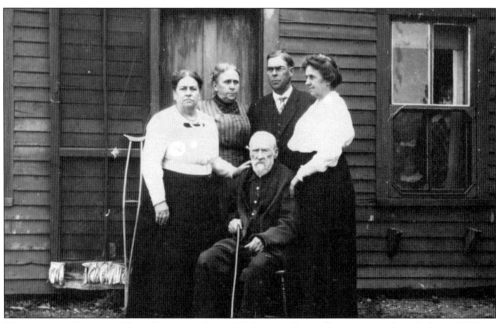

NICKERSON FAMILY. John Quincy Adams Nickerson (seated) is pictured with his children. Behind him from left to right are Abigail Nickerson Trask, Edith Nickerson Stiller, Clifford Nickerson, and Zetta Nickerson Todd. (Sherburne History Center.)

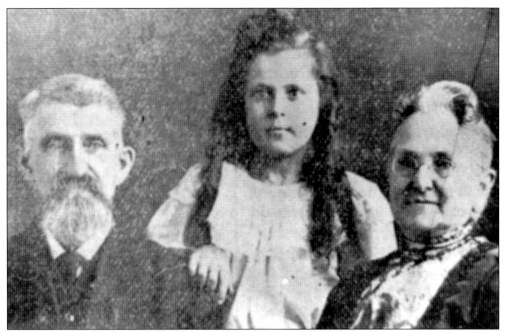

HAPPY GRANDPARENTS. Posing for the camera is E. A. D. Salter, his wife, Francis L. Getchell, and an unidentified granddaughter in 1910. Salter was born in Maine and moved to Minneapolis with his brother-in-law's family in May 1850. His first job was on the steamboat *Governor Ramsey* with Capt. John Rollins, which made regular trips to Sauk Rapids. Salter also worked as a steward at the St. Charles House under landlords J. B. Gilbert, Keith, and Bushnell. Salter married Francis on January 10, 1860, and they had six children. In 1904, Salter and his youngest son, Frank L., bought an interest in the Bank of Elk River, and the family moved to Elk River. (Sherburne History Center.)

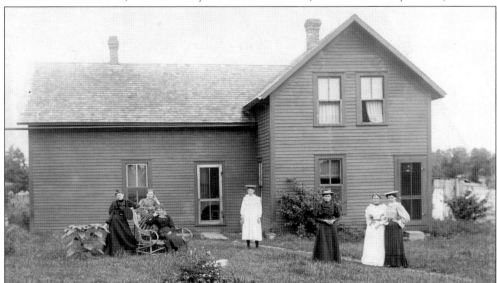

MRS. SARAH MANSUR AND FAMILY. Charles N. Mansur left his wife and family in 1862 to go to the gold fields in Montana territory with Ard Godfrey and others, never returning. In the belief that Charles had died years before, his wife Sarah (Leyerly) applied for a Mexican War Widow's Pension in 1888. Her application was rescinded in 1891 when Charles was found alive in Washington.

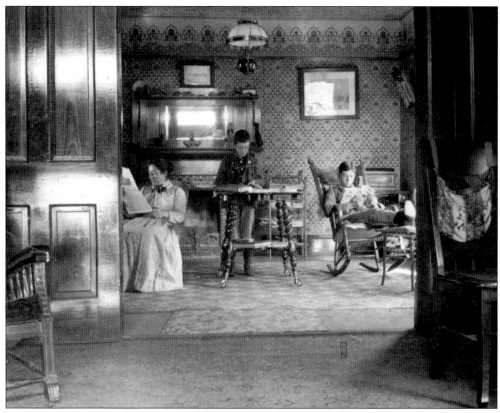

DAVIS PARLOR, C. 1900. Relaxing in their home's parlor are Lucia, Carl, and Earl Davis. (Sherburne History Center.)

ELK RIVER PHOTOGRAPHER. Hiram Horton Mansur was the fourth child of Charles N. Mansur and Sarah Leyerly Mansur. He was a professional photographer in Elk River for a number of years, later moving to St. Cloud. He was born in Minneapolis in 1858 but grew up in Elk River. He never married and was brought back to Elk River to be buried in Orono Cemetery when he died in 1919.

STATE LEGISLATOR. Arthur N. Dare arrived in Minneapolis from New York in 1867. Working in the *Tribune* office, he learned the printing business. He came to Elk River on a visit in the fall of 1875 and became employed by a local editor. In February 1878, he purchased a half-interest in the newspaper, and the following February, he purchased the other half and became the sole proprietor. Later in life, he served as an influential member of the Minnesota State Legislature during sessions in 1895, 1897, and 1899. He served as speaker of the last session and was one of the best-known Republicans in the state. He sponsored a movement to build a jail in Elk River to lock up those who became dangerously unruly during the time the railroad terminated there. Shortly after the jail's completion, however, some of the lawless secured gunpowder, placed it under the jail and lit it, and the structure was completely obliterated. (Minnesota Historical Society.)

A Quiet Moment. Zetta Nickerson Todd and four-year-old Robert (Bert) A. Trask are pictured in 1897. (Sherburne History Center.)

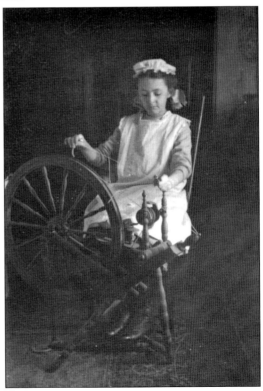

Spinning. Lillian Keays is busy at work on her spinning wheel in 1915. She was born in 1905. (Sherburne History Center.)

Mrs. Lucia Davis. Posing for this photograph is Lucia A. Hifel, who married Herbert H. Davis on November 29, 1884. (Sherburne History Center.)

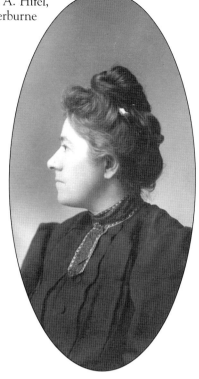

Hometown Carpenter. W. F. Chadbourne and his wife are posing for the camera at their 50th wedding anniversary celebration in 1918. Chadbourne constructed many of the buildings in Elk River, including the band shell, the Elk River School, the first bridge in 1906, and the Union Church. (Sherburne History Center.)

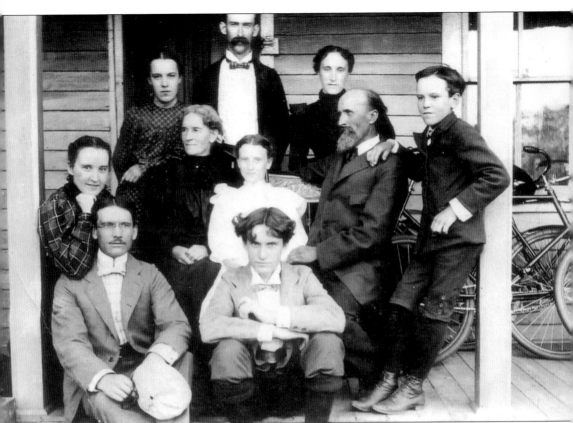

WEDDING GATHERING. Sitting on the steps to their home are James Mortimer and Sarah England Moores with their children and son-in-law. This photograph was probably taken on the occasion of John A. Cranston and Margery (Madge) Moores's wedding in 1898. Pictured from left to right are (first row) Harvey Edwin Moores and James Ernest Moores; (second row) Lavinia E. Moores, Sarah, Lucy Grace Moores, James Mortimer, and Earl Emera Moores; (third row) Anna May Moores, John A. Cranston, and Margery. On July 12, 1899, 17-year-old James Ernest was struck by lightning and killed. His father, James Mortimer, and older brother Edwin were in New York at the time for Margery's funeral. (Courtesy of Linda Kelly.)

EDWIN H. STAPLES. Edwin H. Staples was born in Maine on July 11, 1848. He came to Elk River in 1870 and worked as a miller. On January 1, 1871, he married Esta Mabie of Elk River, and they had two children. Staples became the mail carrier on rural free delivery route No. 2 and continued until Bright's disease (inflammation of the kidney) forced him to give up working. (Courtesy of Janet Panger.)

ANDREW DAVIS. Starting out as a delivery boy for H. H. Wheaton, a business on the east side of the railroad tracks, Andrew Davis worked here until the fire of 1898. His next business venture was to open Heebner Davis and Company in the newly completed Houlton Block after the fire of 1898. The store and building were destroyed by fire in 1902. (Sherburne History Center.)

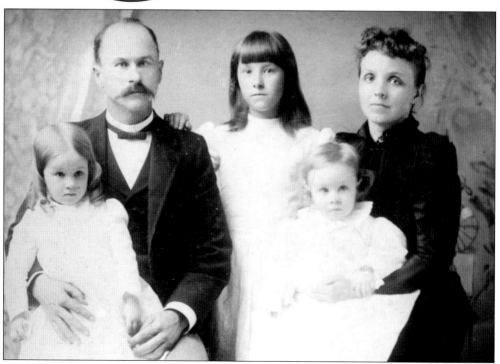

FRANKLIN L. FRYE FAMILY. Franklin and Elizabeth (Staples) Frye are pictured with their children. From left to right are Phyllis, Mabel, and Kent. (Courtesy of Janet Panger.)

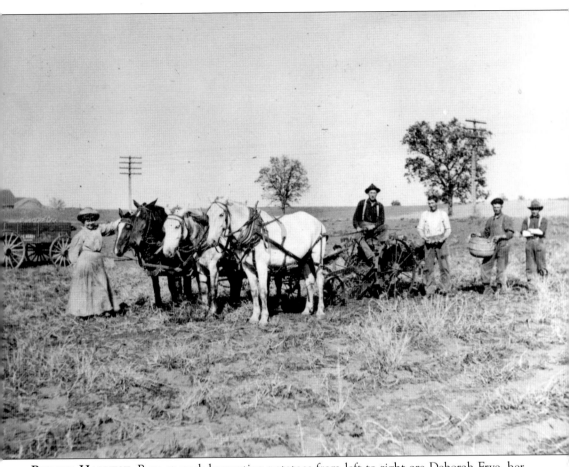

Potato Harvest. Busy at work harvesting potatoes from left to right are Deborah Frye, her father, Will Frye, and three unidentified hired men. (Courtesy of Janet Panger.)

REVEREND STAPLES. Rev. Jotham Sewell Staples was born in Temple, Maine, on June 15, 1823. Around 1869 he moved to Elk River, where on November 6, 1876, his wife Sarah A. (Kennison) Staples died. In 1878, he moved to Vermont but later returned to Elk River. In May 1880, he married Avilda Hasty and moved to Geneva, Nebraska, to take charge of a Methodist church. While in Elk River, Staples was pastor of the United Christian Society and, after a time, became pastor of the Baptist Church. For several years, he was also the editor of the old *Elk River News*. (Courtesy of Janet Panger.)

REFLECTIVE MOMENT. Posing for this photograph is Mrs. Lucia Davis in August 1900. (Sherburne History Center.)

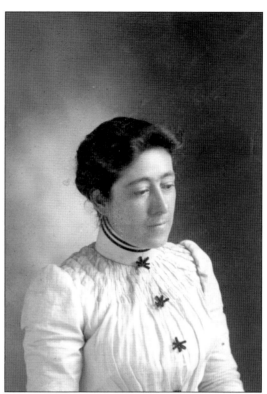

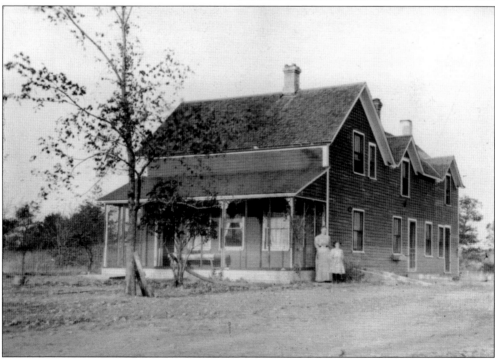

FRYE FAMILY HOME. Here is the Frye family home with quarters for hired hands at the rear of the second floor. The woman and girl are unidentified. (Sherburne History Center.)

YIELDS TO DEATH. Posing for this photograph in the 1870s is Estelle E. (Stella) Trask Whittemore, wife of Dr. Nathan K. Whittemore. He passed away June 6, 1907, of Bright's disease. His funeral was one of the largest ever held in the area. Music consisted of two great hymns, "Art Thou Weary" and "Peace, Be Still," sung by Franklin L. Frye, Sam Houlton, R. E. Dare, and Albert Bailey. (Sherburne History Center.)

J. F. LEWIS, DRUGGIST AND APOTHECARY,
ELK RIVER, MINNESOTA.

No. 39584 For ...

B ...

Date, 10—11 189 8 M. D.

WHITTEMORE'S PRESCRIPTION. This prescription written by Dr. Nathan K. Whittemore in 1898 is barely legible. (Sherburne History Center.)

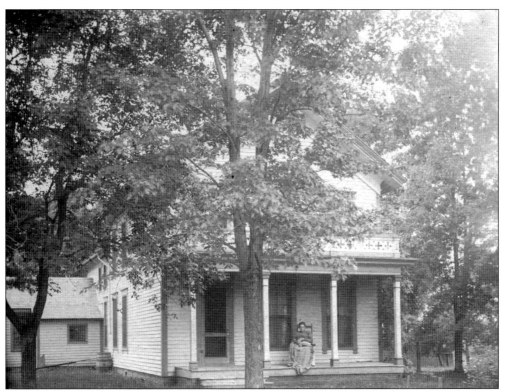

RELAXING AT HOME. This is the home of S. S. and Abigail D. (Nickerson) Trask; the woman relaxing in front of the home is probably Abigail. The photograph dates from the early 1900s. (Sherburne History Center.)

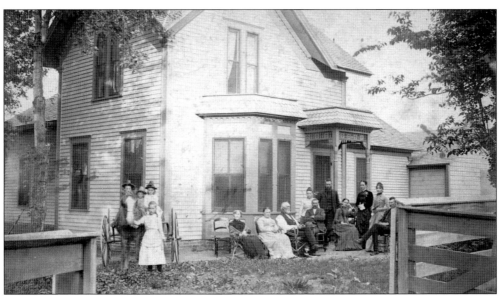

FAMILY GATHERING, 1890. Posing for this photograph by Elk River photographer Henry H. Mansur are members of the Babcock and Godfrey families. (Sherburne History Center.)

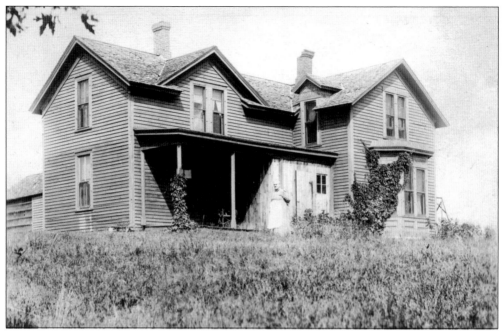

NICKERSON HOME. This was the home of John Quincy Adams Nickerson and his family. (Sherburne History Center.)

HOULTON HOME. This is a photograph of the William Henry Houlton home, possibly from 1910. (Sherburne History Center.)

WOODEN SIDEWALK. Herbert H. and Lucia Davis lived in this home on Main Street. He was a partner in the Davis Brothers store downtown. (Sherburne History Center.)

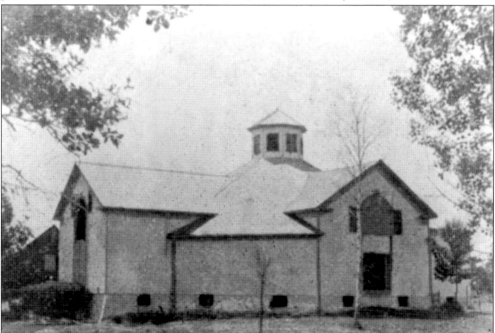

NICKERSON DAIRY BARN. In September 1904, the big barn belonging to the Nickerson brothers burned to the ground after being struck by lightning. They lost 100 tons of hay and much feed. (Sherburne History Center.)

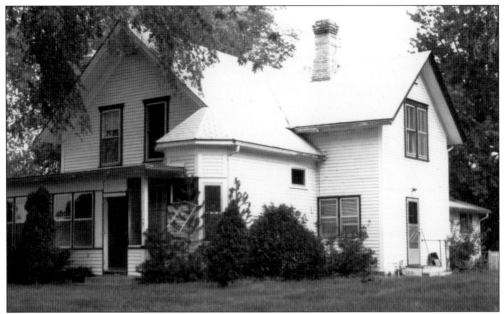

CHARLES WHEATON HOUSE. Charles Wheaton was a leading attorney in Sherburne County and served as the attorney and land agent for the Great Northern Railway. On April 6, 1889, organizers of the Elk River Starch Factory met at Wheaton's office and adopted the Articles of Incorporation. In 1898, the Starch factory burned. This photograph was taken in 1989. (Sherburne History Center.)

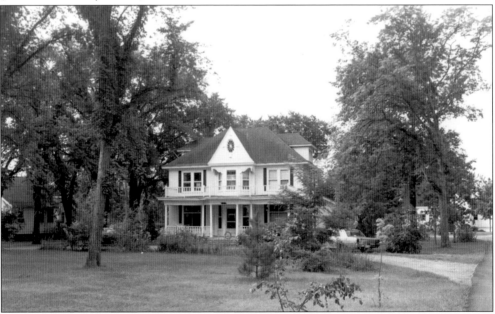

FRANK THURSTON WHITE HOUSE. Frank Thurston White came to Sherburne County from Illinois with his parents in a covered wagon in 1873. He became the oldest practicing attorney in the 18th district, was city attorney for 15 years, and was re-elected for 10 terms. His home was built in 1903 using the Colonial Revival design of the Radford Plan Company of Chicago. It was one of their more elaborate designs. (Minnesota Historical Society.)

DEPUTY SHERIFF FOLEY KILLED IN DESPERATE BATTLE WITH BANDITS

Deputy Sheriff Ed Foley Instantly Killed When He Signaled Bandit's Car to Stop at Temporary
Bridge Across the Elk River.

TRAGEDY FOLLOWED BY FIERCE GUN BATTLE

Desperadoes Make Their Escape in Darkness—Hundreds
of Armed Men Take up Trail and Scour the
Surrounding Country in Search.

BLOODHOUNDS AND AIRPLANES IN THE CHASE

Murderers Apparently Get Away Across Open Country,
Stealing Rig and Two Autoes—Supposed to
Have Gone Northeast.

SHERIFF FOLEY KILLED. In September 1919, Deputy Sheriff Edward Foley was killed on the temporary bridge over the Elk River in upper town by a shotgun blast to the chest. Afterward, Marshall Will Iliff and Sheriff Mert Iliff became engaged in a fierce gun battle with the killers, and when it ended, 50 shots had been fired. Blood in the bandits' car led the lawmen to believe that one of the men had been hit. Although Marshall Iliff was hit twice, he was only slightly wounded. Foley's killers had come from St. Cloud where they had stolen a car. As news of Foley's death traveled, a huge manhunt took place, with hundreds sworn in and deputized. The killers fled on foot, and the dark night made it difficult to see where they went. Two airplanes were sent from Minneapolis to help search the area, including the surrounding islands and riverbeds, and bloodhounds were brought from Waterloo, Iowa, to help. Despite the massive manhunt, the four men eluded authorities, stealing a rig and two automobiles in the process. (Sherburne History Center.)

JOB'S DAUGHTERS. Zetta Nickerson Todd is posing in her Job's Daughters robe. (Sherburne History Center.)

Seven

UP IN SMOKE

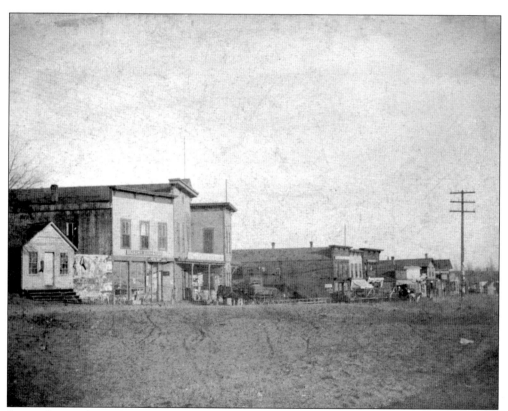

STATE STREET FIRE. One early morning in April 1898, a fire destroyed a two-block stretch of 13 buildings on the north side of the railroad tracks in the downtown business district. By the time the citizens were woken up, the fire was raging out of control and had destroyed 20 businesses. (Sherburne History Center.)

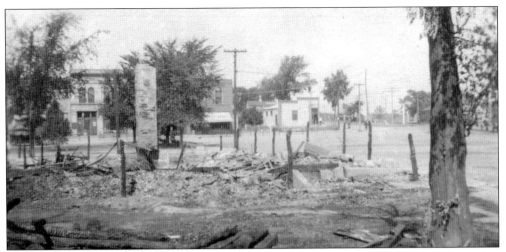

BLANCHETT HOTEL BURNS. This photograph shows the remains of the Blanchett Hotel after an April 1921 fire. Originally this hotel was called the Sherburne Hotel and stood on the triangle now occupied by the Bank of Elk River. (Sherburne History Center.)

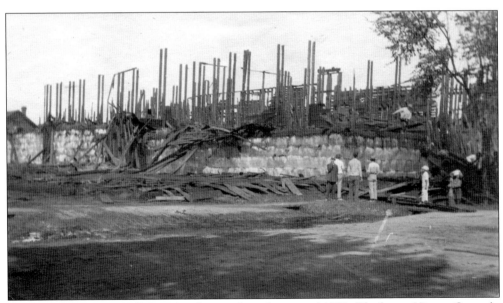

ICEHOUSE FIRE. Here is Elk River's icehouse after a fire around 1900. (Sherburne History Center.)

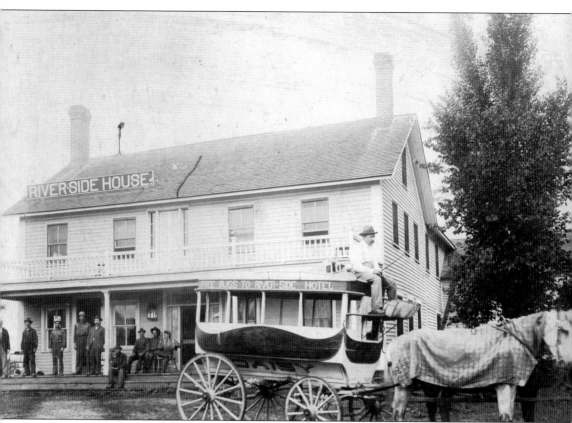

ANCIENT LANDMARK BURNS. In December 1907, the Riverside Inn burned down. The oldest section of it was built 57 years earlier. Originally known as the Elk River House, it was the first hotel in Elk River and was built by Francis Delill for Pierre Bottineau. Nickerson later purchased the hotel and buildings. The Elk River House was used for a variety of events, including the rental of the hall for 13 sessions of court in 1876 and boarding of the Chaplini Coliseum and Circus Comique in 1866 and 1867. During the lifetime of the hotel, its name changed from Elk River House to the Riverside House, and then in 1910, William Henry Houlton renamed it the Riverside Inn and it became a tenement house due to a greater need for more housing. Other owners included Nick Decker in 1892 and L. J. Pratt and Company in 1902. (Sherburne History Center.)

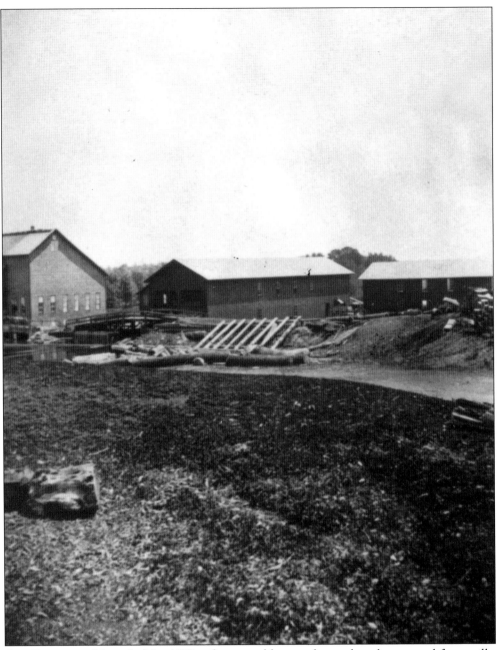

OLD PLANNING MILL. In May 1887, a fire started here and spread to the saw and flour mills. After the fire died down, the entire milling industry in upper town was gone. The sawmills and Houlton Flour Mill employed about 10 men on average. (Sherburne History Center.)

Eight

COMMUNITY AND ENTERTAINMENT

KNIGHTS OF PYTHIAS. Here is an invitation sent to Smith Trask of Elk River for the fifth annual reception and ball put on by the Elk River Knights of Pythias on Thanksgiving in 1883. (Sherburne History Center.)

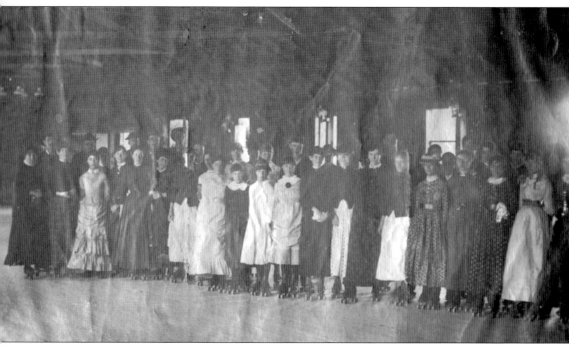

ROLLER RINK MISFORTUNE. In 1884, George Downey and Sam Shorey built a 44-by-120-foot roller rink next to the school. A warning was placed in the *Sherburne County Star News* directed at the boys who carried bottles in their pistol pockets to the roller rink, cautioning them to be careful not to take a tumble. It seems the doctor had to sew up a young boy who had the misfortune the week before. By 1896, the roller rink building was in decline and was purchased and repaired by Dwight R. Houlton and Adelbert Bryant, who were going to use it to store agricultural implements. A fire in the fall of 1900 destroyed the building and all its contents; a successful bucket brigade was able to save the surrounding buildings. (Sherburne History Center.)

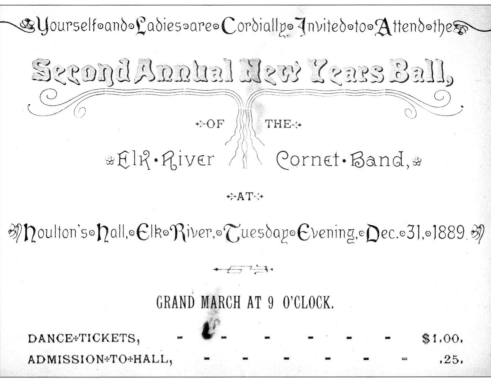

NEW YEAR'S BALL, 1889. Here is an invitation to the second annual New Year's ball of the Elk River Cornet Band. The Committee of Arrangements included O. A. Miller, R. E. Dare, Perry Jones, W. W. Heath, W. F. Chadbourne, C. F. Nickerson, Andrew Davis, and Franklin L. Frye. (Sherburne History Center.)

BOXCAR MURDER. In 1905, the Boxcar Murder Trial came to an end, with C. D. Crawford sentenced to hang for the shooting and murder of Heino Lundin. Arthur Loose (alias George Palmer) was sent to prison. This was one of the last hangings in Minnesota. Judge A. E. Giddings presided over the heavily attended trial. The Sherburne County Courthouse was ready for business in September 1877. (Sherburne History Center.)

CRAWFORD WILL HANG

FIRST DEGREE VERDICT WAS FOUND.

Jury Out From 5 o'clock Till 9:50--Crawford Wholly Unmoved When the Fatal Words were Read, by Clerk of Court, W. V. Davee, but Calmly Lighted a Cigar and Returned to His Cell--Parmer Trial to Follow.

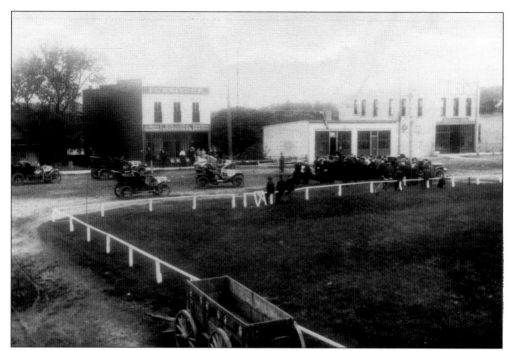

FLIVVER RACE. Racing was a popular pastime in Elk River. The Ford Model T was known as a flivver or tin lizzie and was produced by the Ford Motor Company from 1908 through 1927. The engine had 20 horsepower, and there was a capacity for 10 gallons of fuel. The vehicle weighed about 1,200 pounds. The two-story building on the right side is the present-day sunshine depot. (Sherburne History Center.)

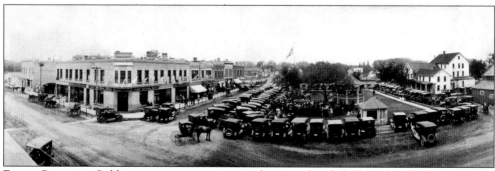

BAND CONCERT. Public concerts were given in the town band shell by the Elk River Cornet Band. They also played at a variety of functions, music hall events, and celebrations. Eventually they became known as the Elk River Community Band. (Sherburne History Center.)

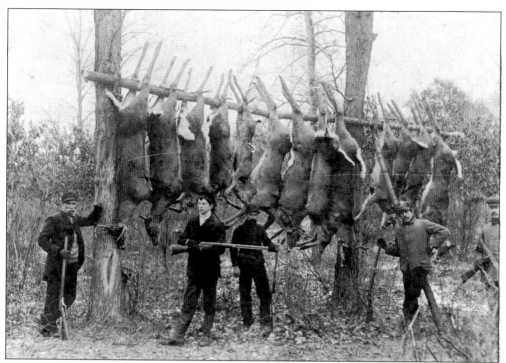

HUNTING PARTY. Here is a 19th-century hunting party. The man at far right might be Clifford Trask. (Sherburne History Center.)

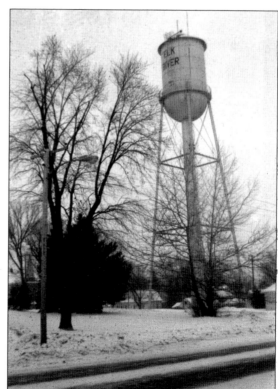

ELK RIVER WATER TOWER. Built in 1920, this has been a recognizable landmark in Elk River for over 80 years. Originally it was painted silver with a red top. (Sherburne History Center.)

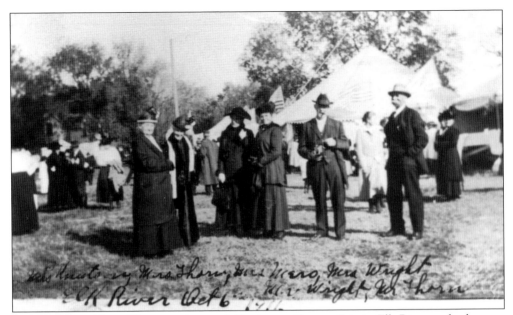

ENJOYING THE FAIR. The second-annual Sherburne County Fair in Elk River took place on October 5–7, 1916. Pictured from left to right are Mrs. Knutson, Mrs. Thorn, Mrs. Mero, Mrs. Wright, Mr. Wright, and Mr. Thorn. The photograph was taken by Lillian Knutson. (Sherburne History Center.)

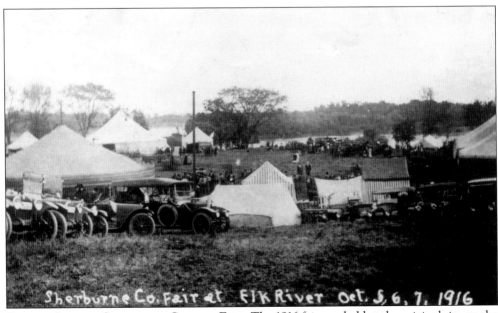

SECOND-ANNUAL SHERBURNE COUNTY FAIR. The 1916 fair was held at the original site on the banks of the Mississippi River just north of where the Elk River flows into the Mississippi River. (Sherburne History Center.)

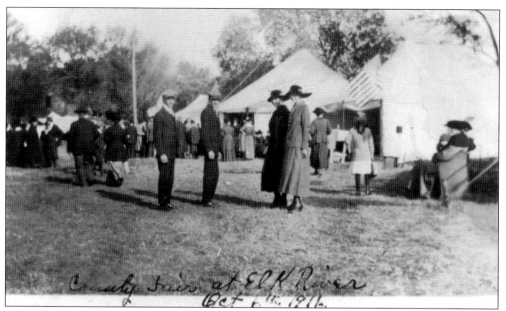

FAIR CROWD. This photograph was taken on October 6, 1916, during the second year of the Sherburne County Fair. The people are all unidentified. (Sherburne History Center.)

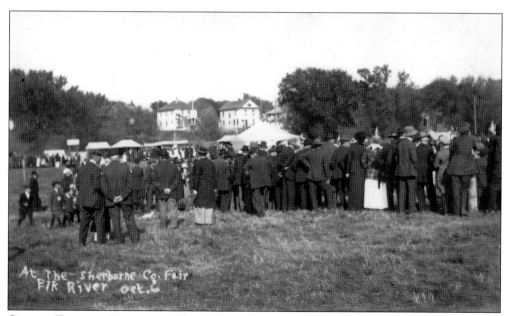

COUNTY FAIR AND BUILDINGS. This photograph was also taken on October 6, 1916. Visible in the background are the houses of Sam Lerner and Anthony Byson Sr. (Sherburne History Center.)

FOURTH-ANNUAL FAIR. Here is the premium list for the fourth-annual Sherburne County Fair, held on October 3–5, 1918. (Sherburne History Center.)

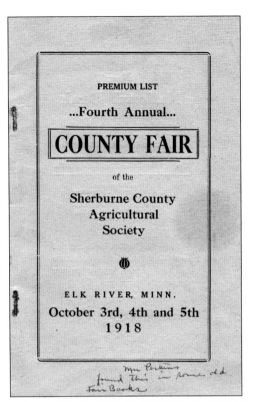

PREMIUM LIST

...Fourth Annual...

COUNTY FAIR

of the

Sherburne County Agricultural Society

✸

ELK RIVER, MINN.

October 3rd, 4th and 5th
1918

Mrs Perkins found this in some old Fair Books

WEDNESDAY, OCT 1
Entry Day
All entries must be made and exhibits delivered at the grounds by 6:00 P. M. No evening program.

THURSDAY, OCT. 2
Homecoming Day

Thursday Forenoon.
Registration of Sherburne County Soldiers, Sailors and Marines at the Village Park, 9:00 to 10:30 o'clock. Parade to the grounds, 10:30. Dinner, 11:30 to 1:00 P. M.

Thursday Afternoon
Band concert, 1:30
Addresses, President S. F. Kerfoot, Hamline University, 2:00; State Representative of the American Legion.
Free attractions and delivery of Victory Buttons, 3:30 to 5:00.
Music will be furnished by John P. Rossiter's Fourth Infantry Band.

Thursday Evening.
Band concert and free attractions, 7:30.
Fireworks, government display of signal and pistol rockets, 8:00.
Dance in pavilion, 9:00.

FRIDAY, OCT 3
Judging and Livestock Day
All judging will commence at 10:00 A. M. in all departments and special attention will be given to this feature.
Music by the Fourth Infantry Band.

Free attractions.
Livestock parade, 1:00 P. M.
Judges—Livestock, W. E. Morris and J. B. McCalla; Poultry, N. E. Chapman; Farm Crops, C. P. Patterson; Women's Department and Schools, Miss Bull.

Friday Evening.
Band concert and free attractions at 7:30.
Government display of fireworks, 8:00.
Dance in pavilion at 9:00.

SATURDAY, OCT. 4
Combination Sale Day

Saturday Forenoon.
Completion of judging in the various departments.
Band concert and free attractions.

Saturday Afternoon.
Combination Sale at 1:00—Sixty head of Shorthorn, Angus, Red Poll, Guernsey, Hereford and Holstein cattle; Duroc Jersey, Poland China, Chester White and Berkshire swine. There will be 20 head of pure bred cattle as follows: Five Milking Shorthorns, 5 Holsteins, 2 Aberdeen Angus, 2 Red Polls and 1 Ayrshire, and 40 head of pure bred swine, consisting of 12 Chester Whites, 14 Berkshires, 8 Poland Chinas, and 4 Duroc Jerseys. Also one pure bred Shetland pony, a mare. Auctioneers, B. E. Benson, H. C. Murray, J. W. Putney and O. N. Ness.
Band concert and free attractions during the afternoon.

Saturday Evening.
Band concert and free attractions, 7:30.
Government display of fireworks, 8:00.
Dance in pavilion at 9:00.

THE SHERBURNE COUNTY AGRICULTURAL SOCIETY

OFFICERS
G. S. HuntPresident
Mike KaliherVice President
Andrew DavisSecretary
L. K. HoultonTreasurer

DIRECTORS
G. S. Hunt Thos. H. Daly
L. K. Houlton A. A. Iliff
Andrew Davis B. F. Plummer
J. H. Miller Mike Kaliher
H. B. Nickerson

SUPERINTENDENTS
Horses—E. E. Scott; Assistant, Dr. J. A. Jaeger.
Cattle—S. R. Houlton, Dairy Cattle; Fay Putnam, Beef Cattle.
Swine—W. W. Bowers.
Sheep—W. W. Bowers.
Poultry—Earl Landon.
Farm Crops—B. F. Plummer.
Fruit and Honey—B. F. Plummer.
Women's Department—Mrs. B. F. Plummer; assistants, Miss Mary Hayden, Mrs. G. H. Tyler, Mrs. G. E. Parsons, Mrs. E. W. Dickey.
Young People's Department—Field and Garden Crops, W. T. Parry; Educational, Mrs. Ada P. Conger; assistants, Prof. J. W. Barton, Mrs. J. H. Miller.

FIFTH-ANNUAL FAIR. This is the program from the fifth-annual county fair, held in Elk River on October 1–4, 1919. This program belonged to Stella Jones, who was 13 years old and won the first and second premium prizes for her "fancy work." (Sherburne History Center.)

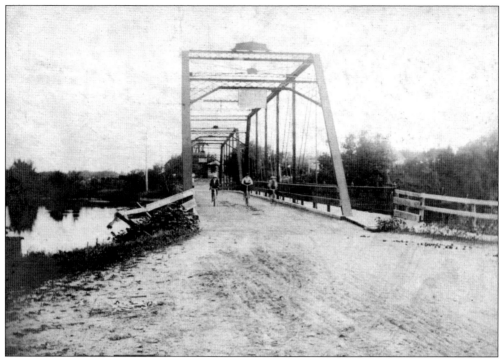

BICYCLES ON BRIDGE. Three bicyclists are shown crossing the Elk River on the Orono Bridge. Anyone could join the Elk River Bicycle Club by paying 50¢ in dues. The money was used to build bicycle paths around town. (Sherburne History Center.)

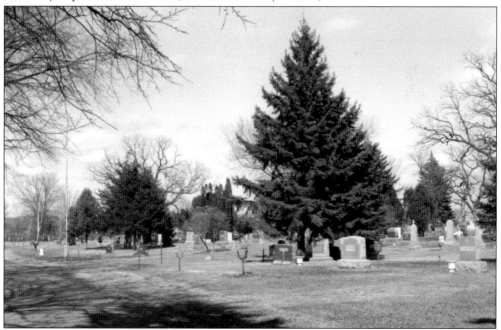

ORONO CEMETERY. The Orono Cemetery is the oldest one in Elk River. The first grave is that of Lucretia Woodword in 1855. Numerous Civil War soldiers' graves are found here along with early pioneers. Orono Cemetery is located on the south side of Lake Orono. (Sherburne History Center.)

VERNON CEMETERY. The Vernon Cemetery was established by John Quincy Adams Nickerson and his wife, Julia (Farnham) Nickerson. The cemetery was named in honor of their young son Vernon who drowned on March 31, 1872. The cemetery land was deeded in 1878 and it is located west of Evans Street on Railroad Drive. Many early Elk River pioneers are buried in the cemetery along with numerous Civil War soldiers. (Sherburne History Center.)

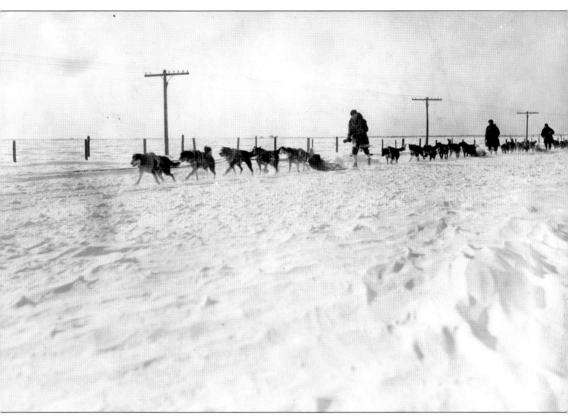

RED RIVER DERBY. In 1917, the St. Paul Winter Carnivale cosponsored the Red River-St. Paul Derby. The dogsled race followed the old Red River oxcart trail from Winnipeg, Manitoba, to Como Park in St. Paul. Eleven teams started, but five were eliminated before the contest ended, including Michael Kelly, one of the two Americans in the race. Frederick Hartman, the remaining American, became the favorite of those in the United States. The *New York Times* and the *Washington Post* followed his progress. Despite the cold temperatures, people lined the streets, cheering on the racers as they passed through each town. (Minnesota Historical Society.)

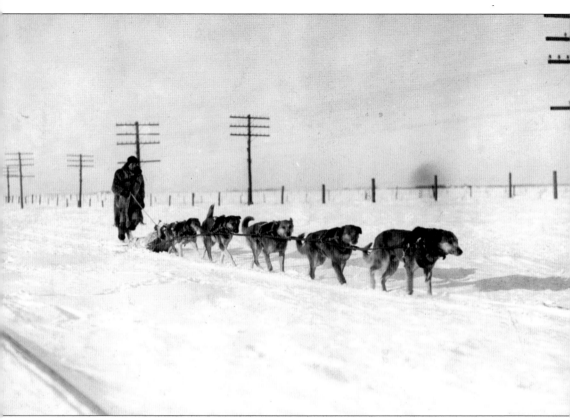

ALBERT CAMPBELL WINS. Albert Campbell, along with his brother Gabriel, entered the race, fulfilling their father's dying wish. Albert and Gabriel were Canadian *metis* (part French, part Cree) from Le Pas, Manitoba. During the race, the Canadian government broadcast news of the brothers' progress to the troops fighting overseas. Albert Campbell finished first, Bill Grayson placed second, Joe Metcalf came in third, and Gabriel Campbell was fourth. Frederick Hartman finished last, arriving four hours later. Even though Hartman came in last, he received $1,000 that had been collected by his fans. The winning prize was $500, more than a year's wages for most. (Minnesota Historical Society.)

Nine

WORSHIP AND LEARNING

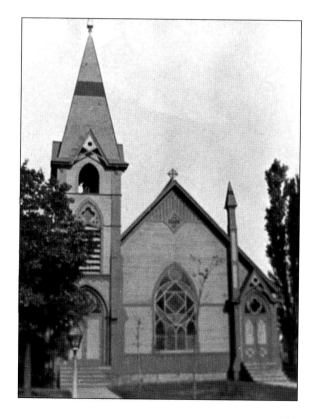

UNION CHURCH. This photograph of the Union Church in Elk River is from 1897. The members decided to build a church in 1881, which was designed and constructed by W. F. Chadbourne of Elk River. It was painted by W. T. Strubble, the masonry was done by Sam Daniel and W. B. Becker, and the tin-work plumbing was completed by Charles Nash. (Sherburne History Center.)

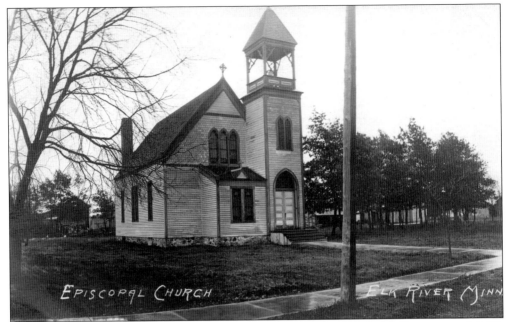

EPISCOPAL CHURCH. This photograph shows the Episcopal church in Elk River around 1900. (Sherburne History Center.)

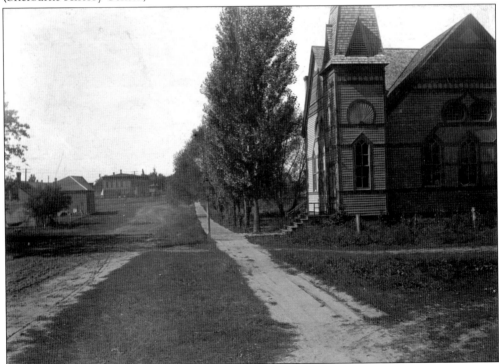

METHODIST EPISCOPAL CHURCH. The original Methodist Church was founded in 1875. The congregation met in the Orono schoolhouse until a church was built north of the railroad tracks in 1889. A new church was erected in 1916 along the Jefferson Highway near Minnesota Street. (Sherburne History Center.)

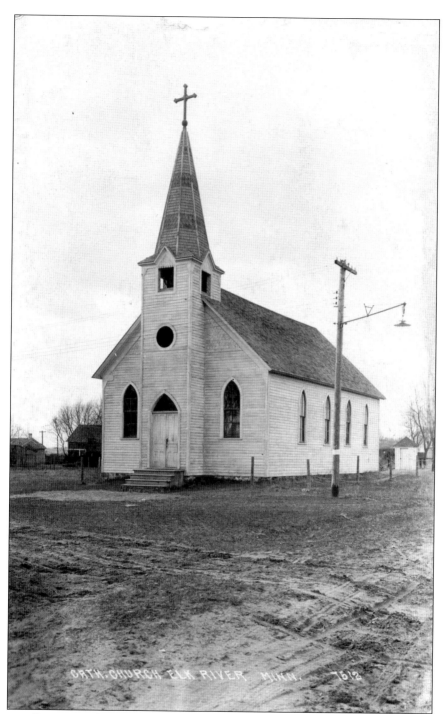

CATHOLIC CHURCH. This photograph of St. Andrews Parish Catholic Church is from 1912. St. Andrews was organized in 1891 by the Holzems, McVissens, McBrides, Halters, Madsons, Fausts, Deckers, and Moegers, under the supervision of Fr. Patrick Mooney. In 1892, a frame church was built under the guidance of Fr. Charles Pheiffer. In 1918, Fr. Joesph Trobec was appointed the first resident priest. (Sherburne History Center.)

CLASS PICNIC. Shown here is a group of Elk River schoolchildren on a picnic in 1904. They are identified by first name and last initial only: Bessie N., Leslie H., Mabel A., Wallace H., Mabel F., Arthur N., Elin H., Otis C., Naomi J., Phil B., Ruth H., Earl N., Anna A., Roy U., Elsie T., Leo B, Sadie R., and Elvina B. (Sherburne History Center.)

HIGH SCHOOL GRADUATES. Shown here is the 1905 graduating class of Elk River High School. The students are identified as Anna Fournier, Nettie Thomas, Daniel White, Carl Davis, Fred Blanchette, Harold Rand, Charles Houlton, and Arthur Bailey. (Sherburne History Center.)

PROFESSOR CONSER. Posing for this photograph is Prof. C. C. Conser, elected superintendent of Elk River schools in 1905. A county superintendent of schools was appointed as early as 1866. (Sherburne History Center.)

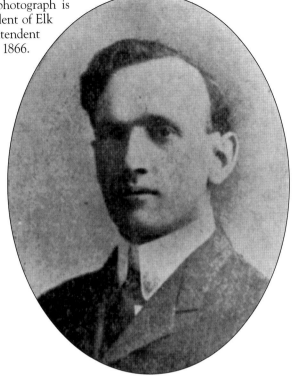

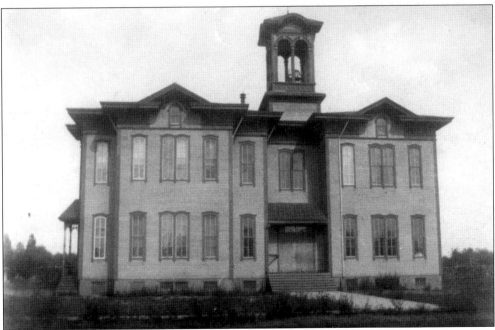

ELK RIVER SCHOOL. This photograph of the Elk River frame school is from the late 19th century. Orono had a school built in 1857; however, students in the village of Elk River had to wait until 1869. A fire destroyed the Elk River school in 1883. A new two-story school for all grades was built by W. F. Chadbourne for $2,450. (Sherburne History Center.)

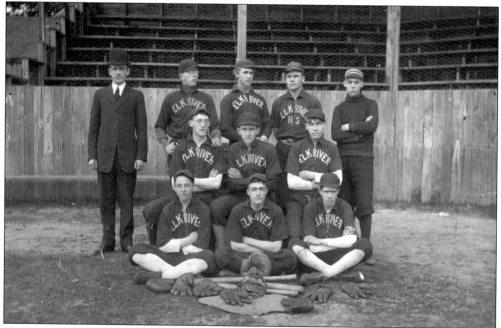

SCHOOL DIPLOMA. The state high school board awarded Mertie Mansur her high school diploma in 1896. (Sherburne History Center.)

BASEBALL TEAM, 1908. Posing for this 1908 Elk River High School baseball team photograph are Lewis Castle, Claud Martens, Leonard Hill, Harry Hill, Richard Lotta, Earl Martens, Walter Anderson, Carl Anderson, Leo Blanchette (captain), and Earl Davis. (Sherburne History Center.)

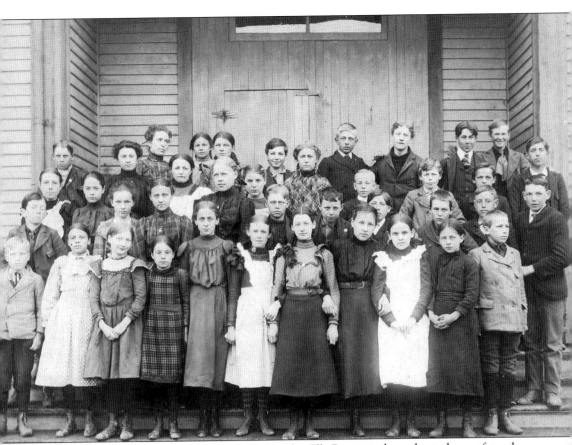

SIXTH-GRADE CLASS, 1899. Shown here are the Elk River sixth-grade students of teacher Blanche Gilman. From left to right are (first row) Earl Nickerson, Florence Hayden, Maude Stevens, Ruth Hayden, Sadie Colson, Lucille Hildreth, Grace Dickey, Lucille Hindley, Cecil Corey, Mary McBride, and Richard Mills; (second row) Lewis Castle, Marie Wagner, Louisa Trombley, Mable Finch, Effie Barden, Emily Perman, Casper Auspos, Johnnie Hare, Willie Walley, Bennie Mitchell, Frank Roath, and Alfred Brown; (third row) Allie Anderson, Ida Corron, Victoria Corron, Florence Brown, Hilda Ostman, ? Johnson, Willie Gurney, Bennie Baldowsky, and Herbert Fournier; (fourth row) Gilman, Alfa Ostman, Mary Ziebarth, unidentified, Ed Nelson, Bert Olson, Ed Baltzell, and Jim Clute. (Sherburne History Center.)

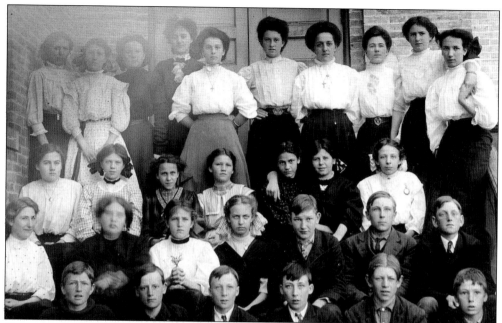

CLASS OF 1903. This is possibly the 1903 graduating class of Elk River High school. Carrie A. Hayden is third from the right in the back row. The other students are unidentified. (Sherburne History Center.)

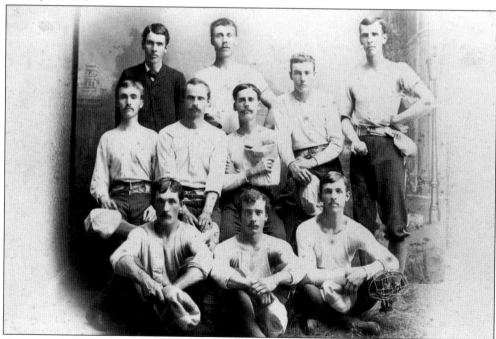

BASEBALL TEAM, 1890s. This photograph of an Elk River baseball team is from the 1890s. Team members included George I. Staples, catcher; O. C. Tarbox, pitcher; H. Vevea, shortstop; J. D. Blake, first base; W. L. Vance, second base and captain; H. D. Mills, third base; S. O. Grover, left field; P. F. Hosch, center field; R. L. Downey, right field; and S. E. Atkins, scorer. (Sherburne History Center.)

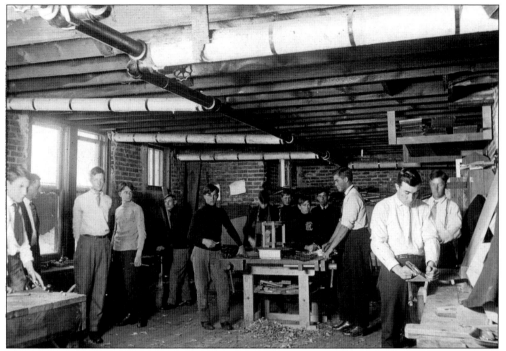

TRAINING CLASS. This photograph of a 1912 manual training class was taken at Elk River High School. (Sherburne History Center.)

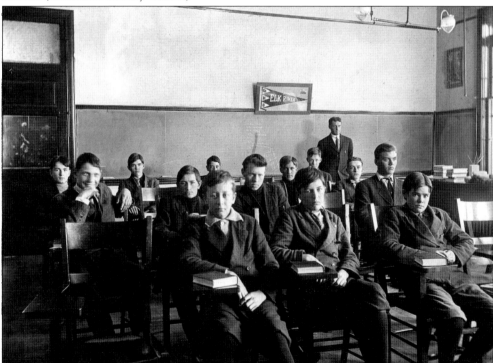

AGRICULTURE CLASS. Everyone in this 1912 photograph of an agriculture class is unidentified. (Sherburne History Center.)

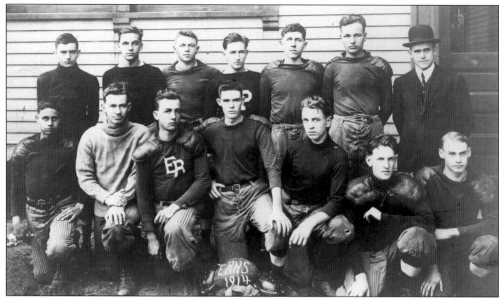

FALL FOOTBALL TEAM, 1914. The photograph was kept by Florence Patch, a teacher in Elk River from 1914 to 1916. She identified the people pictured. From left to right are (first row) Forrest ?, ? Babcock, Harry Nysrom, Ralph Holt, Roger Bishop, Howard Corey, ? Holt, and Ernest Swanson: (second row) Kenneth Davis, Mac Hamlet, Edward McBride, Roy Babcock, David Paul, ? Morsman, and high school superintendent Arthur D. White. (Sherburne History Center.)

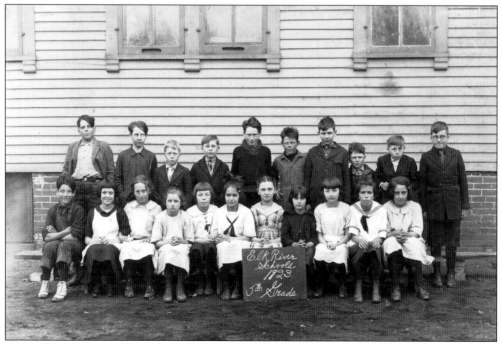

FIFTH-GRADE CLASS. The Elk River fifth-grade class of 1923 is shown here. The students are all unidentified except for George Trask, who is third from the left in the back row. (Sherburne History Center.)

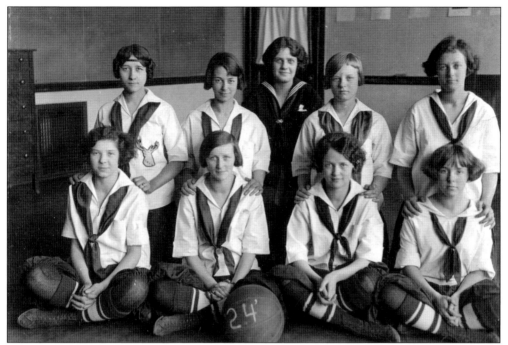

GIRLS' BASKETBALL. In 1924, Helen Trask played on the girls' Elk River High School basketball team. She is at right in the first row. The other players are unidentified. (Sherburne History Center.)

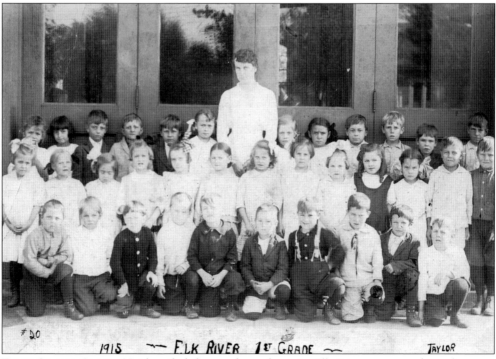

FIRST-GRADE CLASS. Unidentified first-grade students in Elk River are seated on the steps outside of the school building in 1915. (Sherburne History Center.)

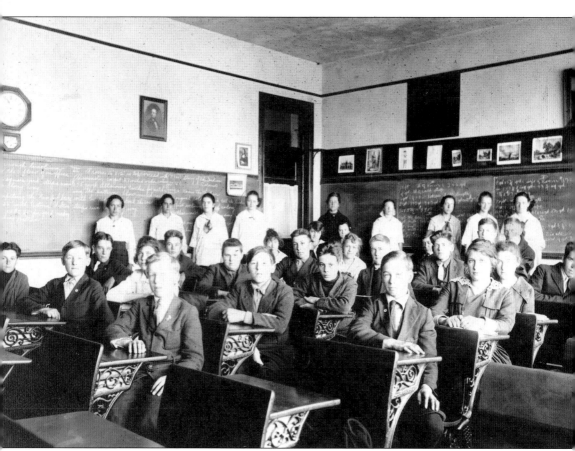

EIGHTH-GRADE CLASS. Here is teacher Hannah Greer's eighth-grade class in 1918. Pictured are David Daniels, Harvey Pajeau, Lewis DeLaitter, Grace Martineau, Ethel Ross, Ethel Byson, Marjie Clark, Wayne Trask, Theo Greupner, Willie Greupner, Fred Wickstrom, Marjorie Ousley, Cassie Thomas, Evelyn Bressler, Pearl Bell, Nellie Playle, Leo Flake, Gerald Iliff, Harvey Gibbs, Ernest McNabb, Alfred Ebner, Bernard Hartfelder, Irene Reavis, Camille Lefebvre, Gladys Erickson, Mildred Parker, Erna Schwanbeck, Chas Simpson, Leonora Hammond, Houlton Benzi, and Carl Dykeman. (Sherburne History Center.)

Ten

GROWING PAINS

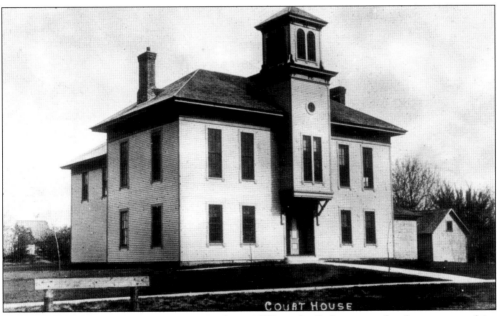

SHERBURNE COUNTY COURTHOUSE. Built in 1877 in the Italianate style, the two-story hip-roofed building was heated by stove until 1915. Vaults were added on the west side between 1898 and 1899. The original exterior had clapboard siding with brick chimneys. In 1890 the courthouse yard served as a pasture for a mare and her colt, who visited each office window on the first floor each day. (Sherburne History Center.)

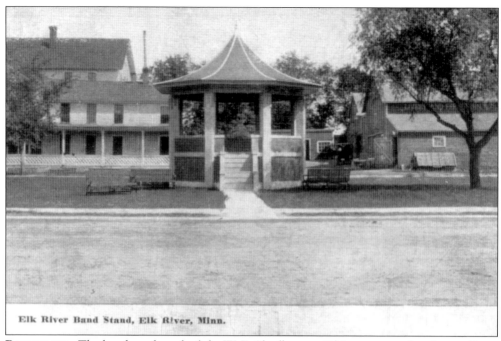

Elk River Band Stand, Elk River, Minn.

BANDSTAND. The bandstand was built by W. F. Chadbourne. This was a popular place to listen to public concerts put on by the Elk River Community Band. In 1884, Professor Richter, the leader of the band, joined the Nickel Plate Circus. (Sherburne History Center.)

CASTLE HOME. In 1880, Henry Castle moved to Elk River. His house was built at a cost of $3,000 in 1885. The large, two-story house was regarded as one of the most handsome in the county. It featured five "devil points" on its roof as decorative trim. These were installed with the belief that they would keep demons from entering from above. (Sherburne History Center.)

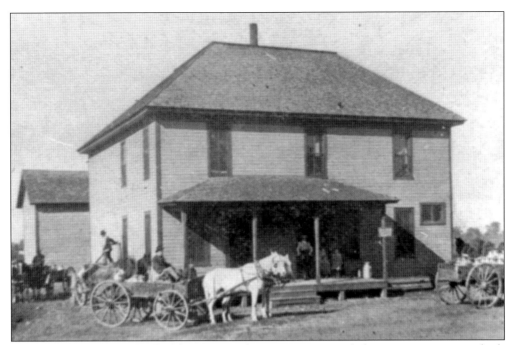

BUTTERMILK FLATS. This building was used as a creamery until the new creamery was built in 1921. Farmers brought in extra milk to sell. This photograph shows wagons delivering milk. Later it was turned into apartments by L. A. Hetrick, then Mattie Millhouse. In March 1971, the building was torn down to make room for the new fire station. (Sherburne History Center.)

ELK RIVER CREAMERY COMPANY. This advertisement was placed in the *Sherburne County Star News* on January 12, 1899. (Sherburne History Center.)

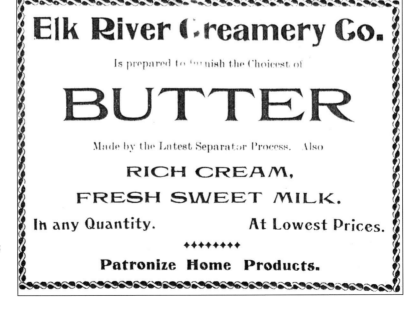

CHARLES M. BABCOCK. Coming to Sherburne County in an oxcart driven by his father, Babcock moved to Elk River as a young man and built a substantial mercantile business. He was appointed to the state highway commission and is credited with building the highway system. His home was torn down to make room for Highway 10. (Sherburne History Center.)

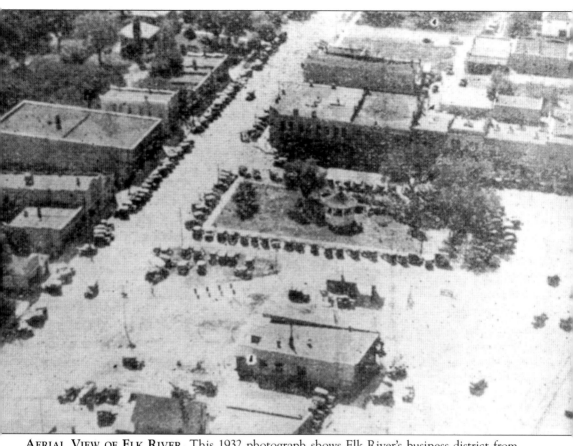

AERIAL VIEW OF ELK RIVER. This 1932 photograph shows Elk River's business district from above. (Sherburne History Center.)

BIBLIOGRAPHY

Folsom, W.H.C. *History of the Upper Mississippi Valley*. Charles S. Wheaton, 1881.

Folwell, William Watts. *A History of Minnesota in four Volumes*. Volume 1. St. Paul, Minnesota: Minnesota Historical Society, 1956.

"Harriet Godfrey Diary 1850–1865." Ard Godfrey Family Papers, Minnesota Historical Society.

Minnesota in the Civil War and Indian Wars, 1861–1865 Volume I. St. Paul, Minnesota: Pioneer Press Company, 1890.

Minnesota in the Civil War and Indian Wars, 1861–1865 Volume II. St. Paul, Minnesota: Pioneer Press Company, 1899.

Executive Documents Printed by the Order of the Senate of the United States for the Second Session of the Forty-Seventh Congress 1882-1883. Volume IV, 1883.

Index to the Rosters in *Minnesota in the Civil and Indian Wars, 1861–1865*. Higginson Book Company, 1994.

Adjutant Generals Report, Minnesota. Military Forces of the United States from 1861–1865. 1866.

Upham, Warren. *A Geographical Encyclopedia*. Minnesota History Society Press, 2001.

Souvenir of Elk River Minnesota. Minneapolis, Minnesota: Wall and Haines, 1901.

Warren, William. *History of the Ojibway People*, Volume 5. Minnesota Historical Society, 1885.

INDEX

www.arcadiapublishing.com

Discover books about the town where you grew up, the cities where your friends and families live, the town where your parents met, or even that retirement spot you've been dreaming about. Our Web site provides history lovers with exclusive deals, advanced notification about new titles, e-mail alerts of author events, and much more.

Arcadia Publishing, the leading local history publisher in the United States, is committed to making history accessible and meaningful through publishing books that celebrate and preserve the heritage of America's people and places. Consistent with our mission to preserve history on a local level, this book was printed in South Carolina on American-made paper and manufactured entirely in the United States.

This book carries the accredited Forest Stewardship Council (FSC) label and is printed on 100 percent FSC-certified paper. Products carrying the FSC label are independently certified to assure consumers that they come from forests that are managed to meet the social, economic, and ecological needs of present and future generations.

FSC

Mixed Sources
Product group from well-managed
forests and other controlled sources

Cert no. SW-COC-001530
www.fsc.org
© 1996 Forest Stewardship Council

Find Your Place in History.